IMAGES
of America

OREGON MILITARY

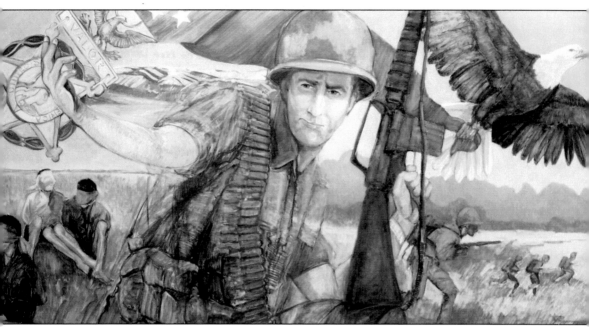

SGT. JOHN NOBLE HOLCOMB. Serving in Vietnam as a squad leader with Company D, 2nd Battalion, 7th Cavalry, 1st Cavalry Division, on December 3, 1968, Sergeant Holcomb's helicopter-deployed unit was attacked three times by a large enemy force. He moved among his men, giving encouragement, directing fire, carrying wounded to safety, and manning a forward machine gun, causing the enemy to withdraw, all at the cost of his life. His valor and sacrifice on behalf of his comrades and his country were recognized with a Purple Heart, Army Commendation Medal with "V" Device, Bronze Star Medal with Oak Leaf Cluster, Air Medal with Oak Leaf Cluster, and the Congressional Medal of Honor. This painting portrays the Baker County valley and mountains where John Holcomb was raised and the Viet Cong prisoners that he rescued from drowning in June 1968. (Carol S. Poppenga painting, Oregon Military Department.)

ON THE COVER: 41ST DIVISION RIFLE PLATOON. This 1930s photograph shows a 41st Division rifle platoon engaged in assault training at Camp Withycombe, Clackamas, Oregon. The men are armed with the M1903 Springfield rifle and M1917 bayonet. The encampment consists of 10-man Sibley tents. (Oregon Historical Society 000641.)

IMAGES
of America
OREGON MILITARY

Warren W. Aney
and Alisha Hamel

Copyright © 2016 by Warren W. Aney and Alisha Hamel
ISBN 978-1-4671-1658-9

Published by Arcadia Publishing
Charleston, South Carolina

Printed in the United States of America

Library of Congress Control Number: 2016941981

For all general information, please contact Arcadia Publishing:
Telephone 843-853-2070
Fax 843-853-0044
E-mail sales@arcadiapublishing.com
For customer service and orders:
Toll-Free 1-888-313-2665

Visit us on the Internet at www.arcadiapublishing.com

To Maj. Gen. Raymond "Fred" Rees, whose inspiring leadership resulted in a strong and ongoing Oregon military history preservation and interpretation program—and this book.

Contents

Acknowledgments		6
Introduction		7
Recognized Heroes		8
1.	Warrior Traditions: Prehistory to 1846	9
2.	Early Indian Wars: 1847–1856	19
3.	Civil War Era: 1857–1871	31
4.	Late Indian Wars: 1872–1880	45
5.	National Guard and the Philippines: 1881–1899	59
6.	Early 20th Century, Mexican Border, and World War I: 1900–1918	73
7.	Interwar Period and World War II: 1919–1945	85
8.	Postwar and Cold War: 1946–1991	103
9.	Post–Cold War and War on Terror: 1992 to present	115
Bibliography		127

ACKNOWLEDGMENTS

Major sources of information for this book included Oregon Adjutant General and Military Department Annual and Biennial Reports (1861–1872 and 1889–1971), Oregon Military Department Public Affairs Office Year in Review reports, the periodical *AZUWUR* (soldier slang for "as you were"), *Oregon Sentinel* newsletters (1991–present), and several published books (see bibliography on page 127). We also used in-house publications such as the *41st Infantry Brigade Combat Team, Jungleers, Operation Iraqi Freedom 2009–2010 Operation Reckless* yearbook, produced by the 41st's public affairs, commanded by Maj. Christopher Reese.

Several Oregon Military Department individuals helped by providing information and images, including M.Sgt. Thomas Hovie and S.Sgt. Jason Vanmourik in the Public Affairs Office and Kris Mitchell, cultural resources manager in the Installations Division.

The Oregon Historical Society provided significant information and images, thanks to Research Library Director Geoff Wexler, Digital Assets Manager Scott Rook, Reference Services Coordinator Scott Daniels, and several other helpful staff members.

Unless otherwise noted, the images in this book appear courtesy of the authors' personal collections. Many also come from the Brig. Gen. James B. Thayer Oregon Military Museum (OMM). Other images appear courtesy of the Oregon Historical Society (OHS), Oregon National Guard (ONG), Oregon Military Department (OMD), Oregon Air National Guard (ORANG), Oregon State Archives (OSA), Salem Public Library Oregon Historic Photographs Collections (OHPC), Smithsonian Institution National Anthropological Archives (NAA), Special Collections University of Oregon Library (UofO), Washington State Historical Society (WSHS), and other organizations and individuals as noted.

INTRODUCTION

Oregon's military history could have begun just a little over two centuries ago with the arrival of naval and army explorers, but it actually goes back thousands of years when we consider the warrior traditions of native peoples. In this book, we try to honor this broad heritage with images and accounts ranging from ancient rock art to 19th-century sketches and etchings to modern photographs and paintings. Due to space constraints, we have had to focus primarily on Oregon's militia history with only some recognition of other military services.

What was once known as the Oregon Country ranged from Northern California to what is now Alaska and from the Pacific Ocean to the crest of the Rocky Mountains. The Lewis and Clark Expedition's Corps of Volunteers for North Western Discovery was the first US Army presence in the Oregon Country. In the 1860s, the Army's District of Oregon included what is now Oregon, Washington, and Idaho.

US Army units were stationed in the Oregon Country and the District of Oregon from 1849 to the present. During the Indian Wars period (1850s–1870s), there were many military units and stations in what became the state of Oregon. By the early 1900s, this had declined to one Army fort and five US Coast Guard stations. There was a small upsurge during World War I and a very large temporary upsurge during World War II. Except for reserve units and seven Coast Guard stations, there is currently a very limited federal military presence in Oregon.

Oregon settlers adopted their first militia law in 1843. During the mid-1800s, there were three levels of military service in Oregon:

1. Oregon Volunteer units organized by the state or federal government for a period of full-time service.

2. The Oregon Militia, consisting of organized, uniformed, and drilled units available for state call-up.

3. The Enrolled Militia, composed of all able-bodied male citizens age 18 to 45 who were listed as members of this paper organization and were also available for state call-up.

Oregon's 1857 constitution did make this exemption in Article X: "Persons whose religious tenets or conscientious scruples forbid them to bear arms shall not be compelled to do so in times of peace, but shall pay an equivalent for personal services."

Today, Oregon's militia has transitioned to three components: the Oregon Army National Guard, the Oregon Air National Guard, and the Oregon State Defense Force. The Army and Air Guard units are uniformed, equipped, and trained to function and serve as capably as their regular full-time counterparts. They are available for both state call-up and federal deployment. The Oregon State Defense Force, an assembly of unpaid and unarmed state service volunteers, is currently in the process of reorganization and redefinition.

Recognized Heroes

The Congressional Medal of Honor is the highest award for combat heroism and was established in 1862. Oregon is credited with these 13 recipients, several of whom are further recognized in this book:

19th Century
Lewis Phife (1841–1913): August to October 1868 in Arizona; Sergeant, US Cavalry, entered service in Marion County

Charles E. Kilbourne (1872–1963): February 5, 1899, at Paco Bridge, Philippine Islands; First Lieutenant, US Volunteer Signal Corps, entered service in Portland

Frank C. High (1875–1966): May 16, 1899, near San Isidro, Philippine Islands; Private, Second Oregon Volunteer Infantry, entered service from Ashland

Marcus W. Robertson (1870–1948): May 16, 1899, near San Isidro, Philippine Islands; Private, Second Oregon Volunteer Infantry, entered service from Hood River.

World War I
Edward C. Allworth (1887–1966): November 5, 1918, at Clery-le-Petit, France; Captain, US Army, entered service from Corvallis

World War II
David R. Kingsley (1918–1944): June 23, 1944, in Ploesti Raid, Rumania; Second Lieutenant, US Army Air Corps, entered service in Portland (posthumous)

Arthur J. Jackson (1924–): September 18, 1944, on the island of Peleliu in the Palau Group; Private First Class, US Marine Corps, entered service in Portland

Stuart S. Stryker (1924–1945): March 24, 1945, near Wesel, Germany; Private First Class, US Army, entered service in Portland (posthumous)

Korean War
Loren R. Kaufmann (1923–1951): September 5, 1950, near Yongsan, Korea; Sergeant First Class, US Army, entered service in The Dalles

Vietnam War
Maximo Yabes (1932–1967): February 26, 1967, near Phu Hoa Dong, Vietnam; First Sergeant, US Army, entered service in Eugene (posthumous)

Gary W. Martini (1948–1967): April 21, 1967, at Binh Son, Vietnam; Private First Class, US Marine Corps, entered service in Portland (posthumous)

John Noble Holcomb (1946–1968): December 3, 1968, near Quan Loi, Vietnam; Sergeant, US Army, entered service from Corvallis (posthumous)

Larry G. Dahl (1949–1971): February 23, 1971, at An Khe, Binh Dinh Province, Vietnam; Specialist Fourth Class, US Army, entered service from Portland (posthumous)

One
WARRIOR TRADITIONS
PREHISTORY TO 1846

Humans have inhabited the region that became Oregon for over 12,000 years. These peoples eventually formed over 100 cultures, many with their own language or dialect, their own traditions, and their own patterns of social organization. They called themselves Cathlamet, Tillamook, Tututni, Molalla, Klamath, Tenino, Modoc, Paiute, Umatilla, Waiilatpu (Cayuse), and Nee-Me-Poo (Nez Perce)—names that often just meant "The People."

Their first contact with outsiders came in the late 1700s when British, Spanish, and American ships explored and exploited Oregon's coastal region. Merchants traded for sea otter pelts and introduced new forms of commerce. They also inadvertently introduced diseases that wiped out 75 to 90 percent of many coastal and interior populations.

In the early 1800s, Russians were in Alaska and venturing south, and Spaniards were in the southwest and venturing north. Canadian explorers and fur traders were heading west. In 1803, Pres. Thomas Jefferson expressed his interest in the American West by organizing what became the Corps of Volunteers for North Western Discovery (Lewis and Clark expedition) with the mission of exploring connections from the Missouri River to the Pacific Ocean.

The success of this military expedition motivated other Americans to head west. Fur traders, trappers, and mountain men were first, followed by missionaries, military explorers, settlers, and merchants. Their destination was called "Oregon Country"—the rich and diverse region west of the Rocky Mountains, north of California, and south of Alaska.

In 1840, the first wagon train immigrants began arriving over the 2,000-mile-long Road to Oregon (also called the Emigrant Road or Oregon Trail). This region was relatively peaceful during these early settlement years. In 1843, Willamette Valley settlers met and organized a provisional government and militia to protect this peace. Over the next few years, there were only a few minor disruptions.

In 1846, the US Congress created the US Regiment of Mounted Riflemen for Oregon Trail duty. However, this unit was diverted to the 1846–1848 Mexican War and did not march into Oregon until 1849.

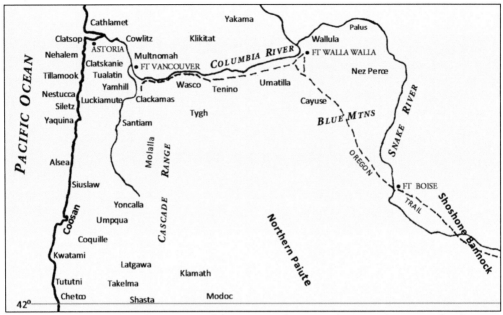

EARLY OREGON. This map shows some of the variety of native cultures in the region that became Oregon, from groupings of related bands such as the Northern Paiute to independent single cultures such as the Cayuse. It also shows the fur-trade posts of the early 1800s such as Astoria and Fort Boise, and the route of the 1840s Oregon Trail.

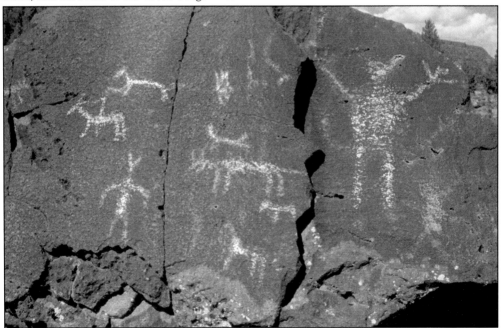

PICTURE ROCK PASS PETROGLYPHS. These south-central Oregon images of humans, animals, and a spirit being were scraped into place on a basalt boulder several thousand years ago (except the image of a human riding an animal, whose patina suggests it was added more recently). This area was occupied by nomadic Northern Paiute. Tenino from the north and Klamath from the west also visited this area, competing with the Paiute.

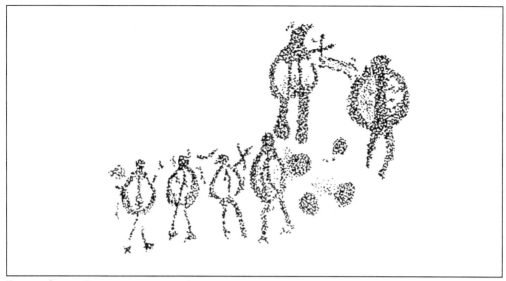

BUTTE CREEK PICTOGRAPHS. Rivalry and competition between cultures sometimes resulted in warrior action to protect territory, resources, family, and honor. This is a stipple tracing of a rock painting in northeastern Oregon. These shield-bearing warriors are standing side by side in pairs, and one of the pairs appears to be striking each other's weapons. (James D. Keyser.)

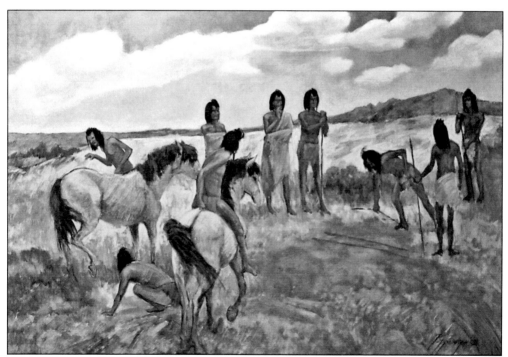

TRADING FOR HORSES C. 1730. According to oral tradition, a Cayuse war party once ventured south into Shoshone territory and saw rival warriors riding on what appeared to be big deer or elk. Deciding to trade rather than battle for these strange animals, they approached their traditional foes, laid down all they had, and acquired one mare and one stallion. (Carol S. Poppenga painting, OMD.)

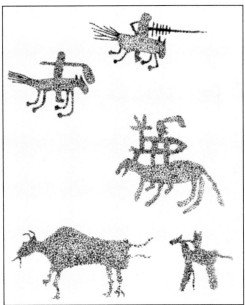

HELLS CANYON PICTOGRAPHS. Horses quickly became an important asset for the Columbia Plateau and Great Basin peoples. Nez Perce and Cayuse of the Columbia Plateau produced huge herds of specially bred stock. For them, travel became easier and more common for big game hunting (including buffalo), for trade with friendly peoples, and sometimes for hostile contacts with rivals such as the Blackfoot and Paiute. (James D. Keyser.)

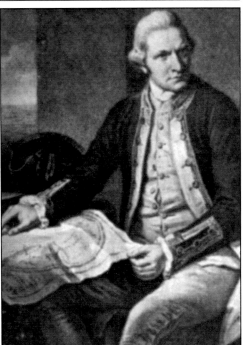
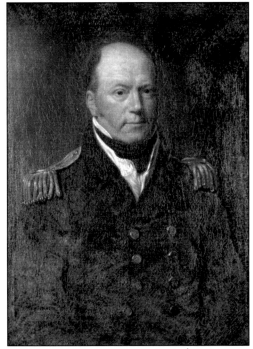

THE FIRST MILITARY PRESENCE. In 1788, British navy captain James Cook (left) sailed up the Oregon coast on HMS *Resolution* but missed sighting the mouth of the Columbia River. In October 1792, British navy lieutenant William R. Broughton (right) crossed the bar aboard the armed tender *Chatham* and sailed 150 miles up the Columbia. He sighted and named Mount Hood and claimed the country in the name of King George III. However, five months earlier in May 1792, American merchant captain Robert Gray, on the ship *Columbia Rediviva*, had already located and entered the mouth of the river and named it after his ship; this gave the United States first claim to the Oregon Country. (Right, National Maritime Museum, Greenwich, London.)

LEWIS AND CLARK REENACTORS. In 1803, President Jefferson directed Capt. Meriwether Lewis to organize an expedition for exploring rivers from the Missouri to the Pacific Ocean. Captain Lewis recruited friend William Clark as co-commander. They organized the Corps of Volunteers for North Western Discovery, composed of US Army volunteers and special recruits (and Captain Lewis's Newfoundland dog Seaman). This expedition boated up the Missouri, reaching its headwaters in August 1805.

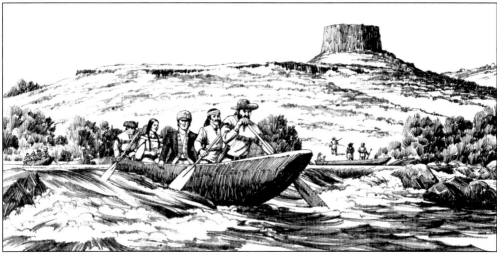

LEWIS AND CLARK AT HAT ROCK. The military expedition was America's first to enter the Oregon Country. In September 1805, they fought snow and hunger in crossing the Rocky Mountains and were welcomed by the Nez Perce with a feast. The corps built dugout canoes and headed downriver, reaching the Columbia in mid-October when they passed and named Hat Rock. (Roger Cooke, artist, Lewis & Clark Trail Heritage Foundation, Oregon Chapter.)

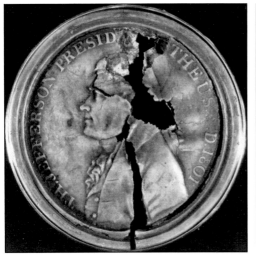 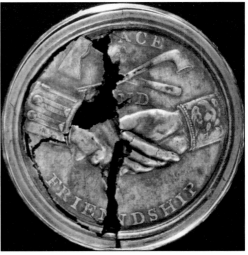

JEFFERSON PEACE MEDAL. This broken medal was found in 1891 on a Columbia River island near Hat Rock, one of the only artifacts from the corps' visit to the Oregon Country. Lewis and Clark gave these medals to Indian leaders as President Jefferson's token of peace. The medals feature Indian and soldier hands clasped in friendship as well as a peace pipe crossed over a tomahawk. (Left, OHS 100141; right, OHS 100142.)

SACAGAWEA AND INFANT SON. The corps had five nonmilitary members, including interpreter Toussaint Charbonneau with his wife, Sacagawea, and their infant son, Jean Baptiste. Before the corps crossed the Rocky Mountains, they encountered a Shoshone band led by Sacagawea's brother. She helped in trading for horses. The presence of Sacagawea was seen as a reconciling token of peace in other encounters. (Lewis and Clark National Historical Park.)

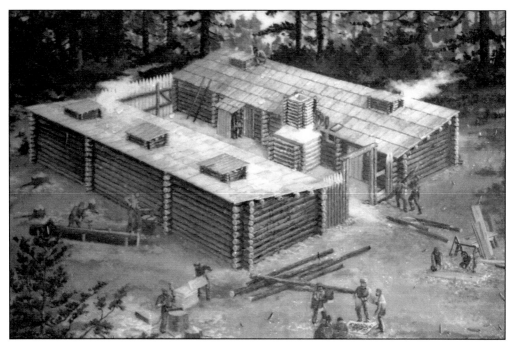

FORT CLATSOP. The corps joyfully first viewed the Pacific Ocean on November 7, 1805. They chose to construct a winter fort near the south shore of the Columbia, naming it after the local Clatsop band. The fort featured rooms for the enlisted and for the Charbonneau family and captains' quarters. The corps spent a miserably wet winter before heading back upriver in late March. (Lewis and Clark National Historical Park.)

MOUNTAIN MAN. The Lewis and Clark expedition's trek across the western mountains stimulated other Americans to head west to the Oregon Country. First came mountain men, fur-trappers, and other adventurers. In 1811, agents of John Jacob Astor and his Pacific Fur Company arrived by sea on the ship *Tonquin*. Next year, the Astor Overland Expedition brought additional trappers and traders.

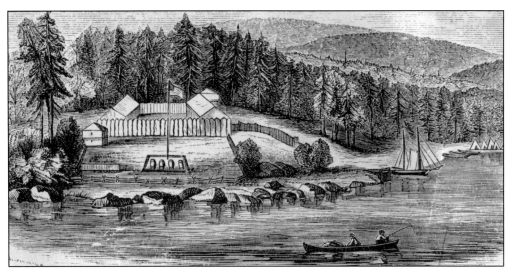

FORT ASTORIA. Pacific Fur Company agents established the trading post Fort Astoria in 1811. However, the War of 1812 and Britain's strong presence in the Pacific Northwest forced its 1813 sale to the British Northwest Company. Capt. William Black of the British navy ship HMS *Raccoon* accepted the post's surrender, replaced the American flag with the British colors, and renamed it Fort George. Local Clatsop chief Concomly offered to defend his American friends.

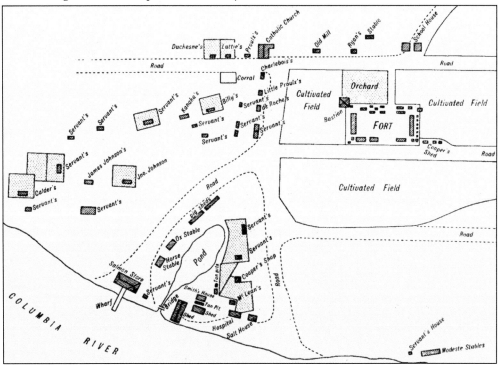

FORT VANCOUVER, 1846. The Hudson's Bay Company of Canada became the dominant fur trader in the Oregon Country, establishing trading posts at Fort Nez Perces in 1818 (renamed Fort Walla Walla in 1821), Fort Boise in 1834, and Fort Vancouver in 1842. In 1849, the US Army established the Columbia Barracks next to Fort Vancouver, and in 1860, the entire complex became an Army post. (Fort Vancouver National Historic Site.)

CHAMPOEG. Many retired trappers and traders and arriving immigrants settled in the fertile and accessible Willamette Valley. In May 1843, these settlers gathered at Champoeg on the lower Willamette River and voted to become part of the United States instead of Canada. They organized Oregon's first government, adopted a militia law, and appointed a major and three captains to begin providing protection for these settlers. (Oregon State Capitol.)

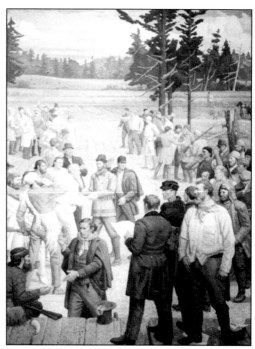

JOHN C. FREMONT. In 1843, Major Fremont led a military exploration into the Oregon Country. He explored southward down the east slope of the Cascades into Nevada and California, charting a route for later pioneer travel. He named many Oregon features along this route, such as Winter Ridge, Summer Lake, and Lake Abert. His exploration party barely survived a winter crossing of the Sierras in California.

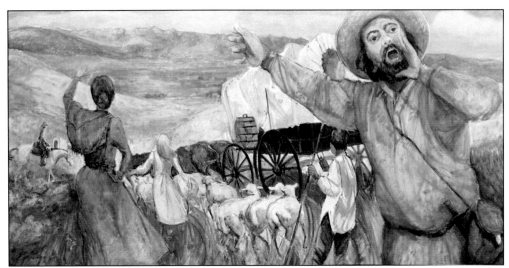

OREGON TRAIL IMMIGRANT TRAIN. In 1843, the first large-scale wagon train immigrations entered Oregon. Over 800 immigrants with 120 wagons and 5,000 cattle made the five-month, 2,000-mile journey. After crossing miles of dry plains, they were pleased to see Oregon's large green valleys framed by high mountains. Since immigrant trains were occasionally attacked, a military presence was sought along this route to Oregon. (Carol S. Poppenga painting, OMD.)

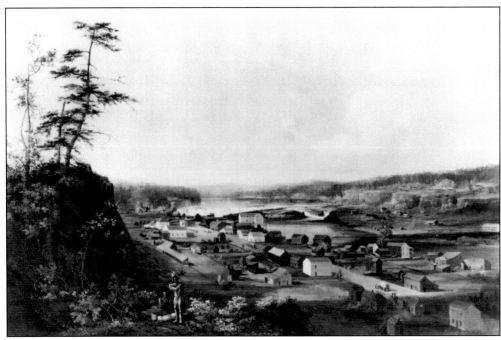

OREGON CITY AND WILLAMETTE FALLS. In early March 1844, encounters at Willamette Falls between two settlers and Wasco Indian Cockstock resulted in four deaths. Oregon's provisional government appointed Thomas Keizer captain and formed the Oregon Rangers, a mounted rifle company. On March 11, this unit met and drilled in Salem as Oregon's first active military unit. This action may have been aimed as much at the Hudson's Bay Company as the Indians. (OHS 23926.)

Two

Early Indian Wars
1847–1856

Before 1847, there were only minor conflicts between Oregon's native peoples and newcomers such as raids on travelers or quarrels over resources. A major conflict ignited in November 1847, when some Cayuse killed Dr. Marcus Whitman, his wife, Narcissa, and nine others at their mission station on the Walla Walla River. Dr. Whitman had medically treated both immigrants and natives, but several Indians died under treatment because of their lack of inherited resistance to introduced diseases. Dr. Whitman was accused of sorcery worthy of death.

The Oregon Provisional Legislature responded by organizing volunteer units that headed east on the Oregon Trail, defeated the Cayuse in battle, and established the temporary Fort Waters near the Whitman Mission site. In March, the volunteers were outwitted in battles near Touchet Creek. Most of them returned to the Willamette Valley and were discharged in July.

In August 1848, an act of Congress established Oregon as an official territory of the United States, with Gen. Joseph Lane appointed territorial governor.

The US Regiment of Mounted Riflemen was stationed in Oregon from 1849 to 1851. Starting in 1852, the First Regiment of Dragoons stationed companies in Northern California, at Fort Yamhill in Oregon, and at Fort Walla Walla in Washington. By the end of 1854, the total US Army force in Oregon Territory was 335 dragoons, infantry, and artillery.

Hudson's Bay Company's French fur brigades had encountered troublesome Indians in what became southwestern Oregon. They named its main river "La Riviere aux Coquins" which translated to Rogue River. With the discovery of gold in 1851, these troublesome encounters escalated. The valley became the center for the Rogue Wars of 1851–1856.

Similar clashes resulted in the Yakima War of 1855–1856 ("Yakima" is the standard spelling for this region's geographic features, and "Yakama" is the preferred spelling for its native inhabitants).

During this period of Indian wars, the behavior of civilian and military leaders towards native peoples ranged from friendly assimilation to attempted annihilation. The behavior of native peoples towards these newcomers ranged from welcoming support to attempted expulsion.

The US Coast Guard first established its presence in the Pacific Northwest with the construction and operation of 16 lighthouses along the coast built between 1852 and 1858 by one of its predecessor agencies, the US Lighthouse Service.

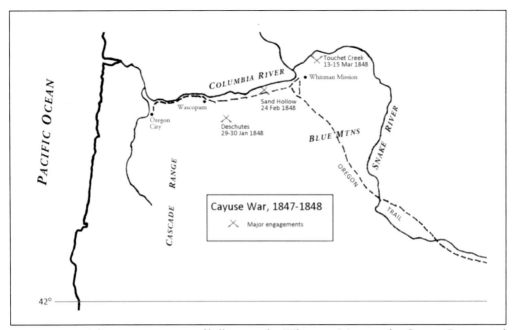

CAYUSE WAR. After receiving news of killings at the Whitman Mission, the Oregon Provisional Legislature immediately authorized forming a company of riflemen to protect citizens at Wascopam (later site of Fort Dalles). The next day, it authorized forming a regiment of 500 mounted riflemen to capture the guilty Cayuse. The Company of Oregon Rifles arrived at Wascopam on December 29, 1847. This map shows major locations and events of this 1847–1848 conflict.

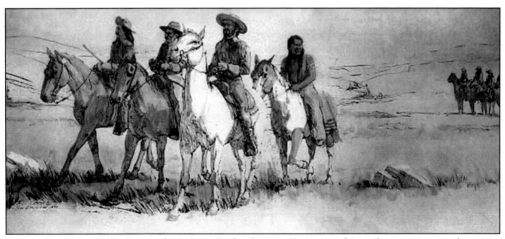

PEACE COMMISSION. On December 14, 1847, the Oregon Provisional Legislature appointed a peace commission to precede the regiment, council with tribes on the Columbia River, and prevent a coalition. Provisional Governor George Abernethy appointed leaders Joel Palmer, Robert Newell, and Henry A.G. Lee to this commission. They departed from Wascopam in February 1848 and established peace with several Tenino, Deschutes, and Yakama bands. (Roger Cooke illustration, Sea Reach Ltd.)

Joel Palmer. One of the Cayuse War peace commissioners appointed by Governor Abernethy, Joel Palmer also served as commissary general for the volunteers. Later appointed superintendent of Indian affairs for Oregon Territory, he negotiated nine treaties and was instrumental in ending the Rogue Wars. Palmer was removed from office because of party disloyalty and his unpopular consideration of Indians. He later served in both the Oregon House of Representatives and Oregon Senate. (OHS OrHi 362.)

Sand Hollow Battle. This major Cayuse War battle occurred on February 24, 1848, just north of the Oregon Trail. Pakhat'aw'aw (Five Crows) was wounded at Sand Hollow by 1st Lt. Charles McKay and fiscally ruined in the Cayuse War. He was a principal spokesman for the Cayuse during the 1855 Stevens Treaty Council at Walla Walla. Charles McKay later served in the First Regiment of Oregon Mounted Volunteers during the Yakima War of 1855–1856. (Left, Gustav Sohon sketch, 1855, WSHS; right, OHS 19919.)

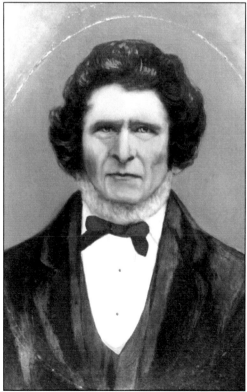

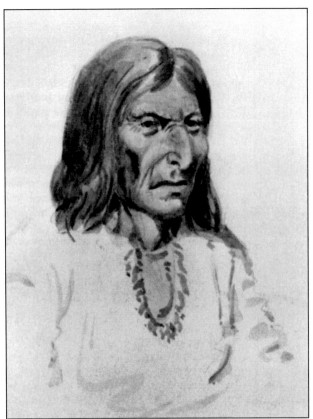

TELOUKAIKT (CRAWFISH ADVANCING). Leader of the Waiilatpu band of Cayuse, Teloukaikt was host, landlord, and interpreter for the Whitman Mission. Although held responsible for Dr. Whitman's death, Teloukaikt had intervened to save 46 mission captives. In April 1850, Cayuse leaders turned Teloukaikt and four others over to Oregon territorial governor Joseph Lane. They went on trial in Oregon City, where they were convicted and hanged. (Paul Kane sketch, 1847, Stark Museum of Art.)

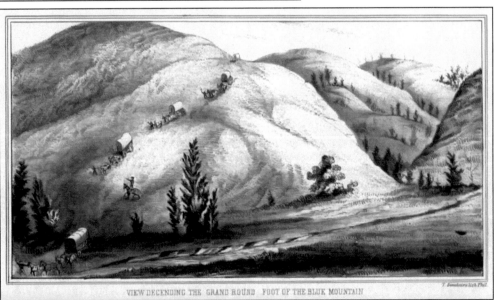

US ARMY ARRIVES. In 1849, the US Regiment of Mounted Riflemen marched 2,016 miles to Oregon. Here they descend the Oregon Trail's steep grade into the Grande Ronde Valley. They reached Oregon City and established a headquarters on October 13. An artillery company arrived earlier by sea and set up quarters at the Hudson's Bay Company's Fort Vancouver.

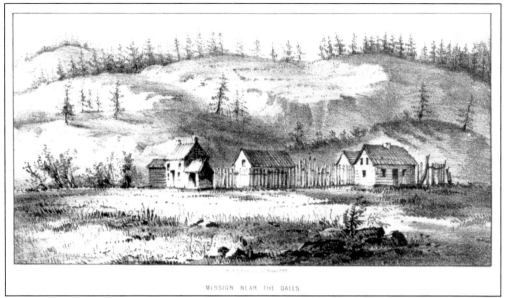

WASCOPAM MISSION. In 1838, Methodist reverend Jason Lee established this mission near the Dalles on the Columbia River. In 1847, Oregon volunteers set up camp here, naming it Fort Lee, then Fort Wascopam. In 1850, two companies of the Regiment of Mounted Rifles established Camp Drum near here. It was renamed Fort Dalles in 1853.

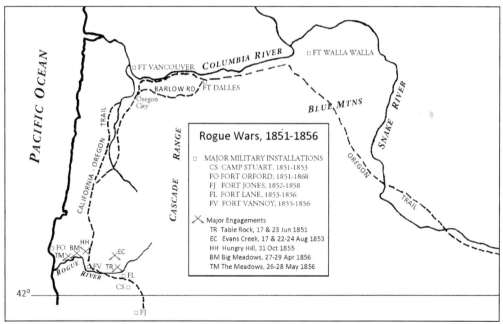

ROGUE WARS, 1851–1856. Travelers to and from California experienced occasional attacks in the Rogue country. California's 1849 gold discovery resulted in more travelers and more confrontations. The 1851 discovery of gold in the Rogue Valley produced an influx of California miners and greatly increased conflicts. This map shows major military events and locations relating to these conflicts. There were at least 20 other minor skirmishes and 21 temporary forts and camps.

JOSEPH LANE. In 1853, there was a major outbreak, and former territorial governor Gen. Joseph Lane was in the Rogue River area looking after his mining interests. He took over command of the army and volunteer forces in the area and attacked Indian positions at Evans Creek. The Indians then offered to talk peace. (OHS OrHi 9169)

TECUMTUM AND NESMITH. In September 1853, the acting territorial governor George L. Curry requisitioned arms from the Army post at Vancouver and sent them south escorted by 40 volunteers under the command of Capt. James Nesmith. The Rogue Indians had offered to talk peace, and General Lane asked Nesmith to accompany him as a Chinook language translator. Unarmed, they and 10 others went into the camp at Table Rock. When the Indians became threatening, Chief John (Tecumtum) intervened and calmed the situation. The Treaty of Table Rock was completed, and peace was restored. When the Rogue Valley Indians were removed to the Grand Ronde Indian Reservation, Chief John became a frequent visitor to the nearby Nesmith home. (Left, OHS 4355; right, OHS 12774.)

CHARLES S. DREW. From 1854 to 1856, Drew served as quartermaster and adjutant with several volunteer units. In October 1855, volunteers from Yreka and Jacksonville attacked an Indian village on Butte Creek east of Table Rock. They killed at least eight men and 15 women and children. Drew said the plan was "admirably executed." (OHS CN 020573.)

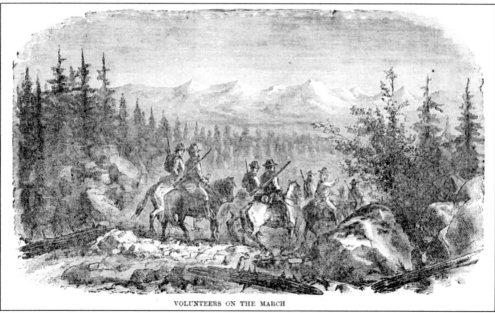

VOLUNTEERS ON THE MARCH. In late 1855, Gov. George Curry organized the Second Regiment of Oregon Mounted Volunteers and sent it to the Rogue country. R. Glisan wrote in his journal: "the troops have insurmountable difficulties to contend with in fighting Indians in Southern Oregon. The country is so impassable and thickly timbered, that the Indians can take their position wherever they please, which is generally impregnable, and if pushed too hard are sure to find a way of retreat."

Lou Southworth. Slave Lewis Southworth played his fiddle in the Rogue gold country, earning enough to purchase his freedom. In 1856, an Oregon volunteer unit encountered him on the trail and asked him (and his horses) to join them. He participated in the last battles of the Rogue Wars, then homesteaded in Lincoln County. He was the Oregon military's first African American member (the next one enlisted in 1955). (Benton County Historical Society.)

Fighting the Indians. The last Rogue Wars actions occurred on the lower Rogue. These included the April 1856 Big Meadows Battle and the Meadows Battle in May, as well as this March 19, 1856, skirmish on Rogue River near the Illinois River mouth. Here, detachments of volunteers attacked a camp on the opposite bank. The Indians fled across the Illinois, and the volunteers burned their camp.

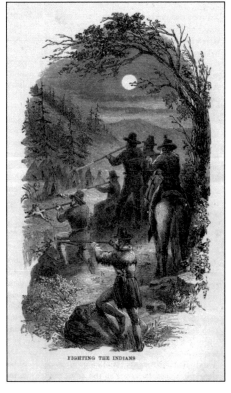

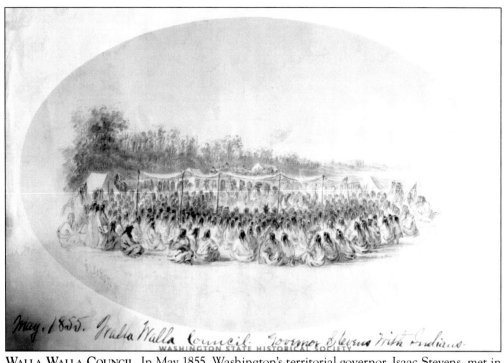

WALLA WALLA COUNCIL. In May 1855, Washington's territorial governor, Isaac Stevens, met in council with Yakama, Cayuse, Walla Walla, Palouse, and Nez Perce leaders. These leaders hesitantly agreed to a treaty establishing the Yakama, Nez Perce, and Umatilla Indian Reservations and extinguishing Indian claims to 22 million acres. Twelve days after the council, Stevens prematurely opened the ceded lands to immediate settlement. (WSHS 1918.114.9.39.)

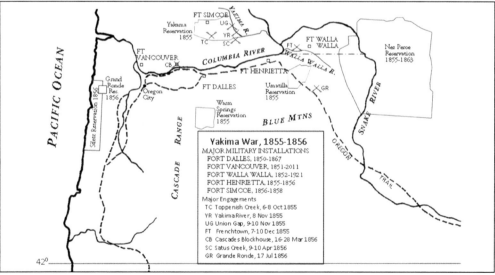

YAKIMA WAR, 1855–1856. Despite the 1855 treaty, some miners began trespassing across Yakama lands after gold was discovered in northeast Washington. Several of these miners were killed in September 1855, and Indian subagent Andrew Bolon was killed when he went to investigate. In early October, an Army expedition from Fort Dalles was attacked at Toppenish Creek and forced to retreat. Army major Granville Haller called for Washington and Oregon volunteers to assist.

WAR LEADERS CORNELIUS AND KAMIAKIN. The First Regiment of Oregon Mounted Riflemen organized in November 1855, with Col. James Nesmith as its first commander. When Nesmith resigned in December, Thomas Cornelius, commander of Company D, was elected to replace him. He led units through several skirmishes and the major Satus Creek battle. Cornelius later served in Oregon's legislature and was a Republican nominee for governor. Kamiakin, an influential Yakama leader, felt he was bullied into signing the 1855 treaty. He was a capable strategist who united many of the Columbia basin tribes for war. Under his leadership, they responded to threats and opportunities from Puget Sound to the Columbia River to the Walla Walla country. After the war, he fled east to Flathead country in Montana, then returned to live off-reservation in his father's homeland. (Left, Washington County Historical Society, photograph 19275; right, Sohon sketch, WSHS 1918.114.9.65.)

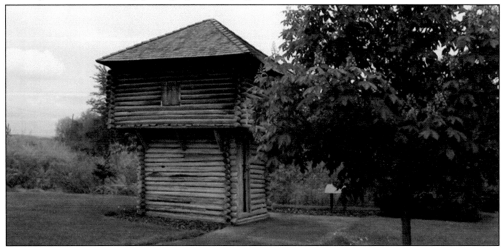

FORT HENRIETTA BLOCKHOUSE (REPLICA). In November 1855, two companies of Oregon volunteers constructed Fort Henrietta on the lower Umatilla River, naming it in honor of Major Haller's wife. By the end of November, four more companies arrived. On December 2–3, all these companies went to the Walla Walla Valley and occupied a site near Frenchtown. Some of these companies returned to Fort Henrietta for the winter. (City of Echo.)

Peo-Peo-Mox-Mox (Yellow Bird).
A principal signer of the 1855 treaty, he was an important Walla Walla leader who apparently tried to work both sides in the Yakima War. On December 6, 1855, he entered the Oregon volunteers' camp near Frenchtown under a flag of truce. He and five companions were taken hostage and then shot during an ensuing battle. Peo-Peo-Mox-Mox's body was scalped and mutilated by the volunteers. (Sohon sketch, WSHS 1918.114.9.64.)

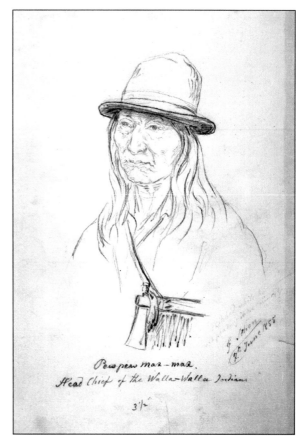

Cascades Blockhouse, c. 1880.
In November 1855, the US Army erected a blockhouse on the Columbia River's north shore near the Cascades. In March 1856, Kamiakin led a surprise raid in an attempt to cut the river's supply line at this site. Two boats escaped and spread the alarm up and down the river. Regulars and volunteers from Fort Dalles and Fort Vancouver broke the siege. (WSHS 2001.0.161.)

INDIANS STAMPEDING HORSES AND MULES. On April 28, 1855, Colonel Cornelius and part of his command of Oregon volunteers encamped on the Columbia River's north side five miles from Fort Dalles. Indians under Kamiakin "made a dash at our horses and run them off," according to R. Glisan. The Indians were already well mounted, but now they had 390 more horses, "some of the finest horses in Oregon."

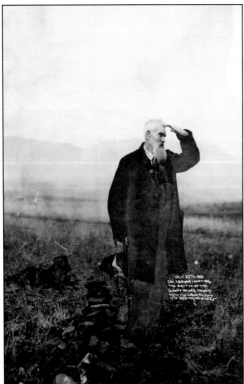

GRANDE RONDE ATTACK. Photographer Lee Moorhouse captioned this image "Oct. 27th 1907. Col. F.B. Shaw locating the Battle of the Grand Rond fought with the Indians July 17th 1856." Washington volunteers under the command of Colonel Shaw ventured far into Oregon and attacked Cayuse families camping at their root gathering grounds in the Grande Ronde Valley. In this last conflict of the Yakima War, nearly 40 Indians were killed. Many were old men, women, and children. (WSHS 2005.0.131.)

Three

CIVIL WAR ERA
1857–1871

Army units in the Pacific Northwest before the Civil War included elements of the First Dragoons, the Third Artillery, and the Fourth and Ninth Infantry Regiments. They initially engaged in conflicts with the Spokane, Palouse, Yakama, Coeur d'Alene, and others in northeast Washington Territory. By 1860, the primary region of conflict shifted to the Great Basin and Snake River areas of southeastern Oregon and southern Idaho. These conflicts were called the Snake Wars, since settlers and the military tended to lump this region's Shoshone, Bannock, and Paiute under the title Snake Indians.

On April 12, 1861, the Civil War broke out. Many officers in the Army's Department of the Pacific were ordered east to become Union leaders (a few resigned and joined the Confederate army). Most regular units were then sent east, and a call went out to the states and territories to replace these units with volunteer regiments. California raised 10 regiments. Oregon and Washington were slower to respond, so two of California's regiments were sent to the District of Oregon. Companies went to Fort Dalles, Fort Vancouver, Fort Walla Walla, Fort Hoskins, Fort Yamhill, Fort Steilacoom, and Fort Colville. Most were withdrawn by late 1862, and none saw any action during this duty tour.

In November 1861, the US War Department appointed Cayuse and Yakima War veteran Thomas R. Cornelius a colonel and directed him to raise a regiment of cavalry for three years of service. Seven companies mustered into federal service. In October 1864, the War Department asked Oregon governor A.C. Gibbs to raise a regiment of infantry, and 10 companies mustered in. These volunteer cavalry and infantry units campaigned throughout the Pacific Northwest. At least 27 Oregonians died while in this service.

In 1863, Cyrus A. Reed, the first adjutant general of Oregon, organized seven companies of Oregon Militia as the state's first uniformed and drilling part-time military. By 1867, there were 16 companies in the Oregon Militia.

On April 9, 1865, the Civil War ended. In 1866, regular Army units began returning to the Pacific Northwest, and Oregon volunteer units mustered out.

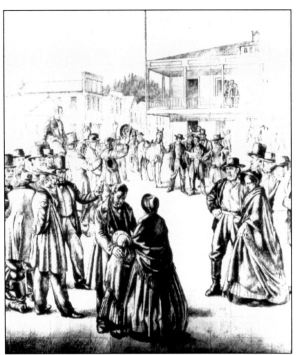

RECEIVING NEWS OF STATEHOOD. On February 14, 1859, Oregon became the 33rd state of the union. Oregon had no organized military forces during this period, just a paper list of able-bodied male citizens between the ages of 18 and 45. The state constitution defined how this state militia should be organized, and exempted persons who had "religious tenets or conscientious scruples" against serving. (OSA OCR 0005.)

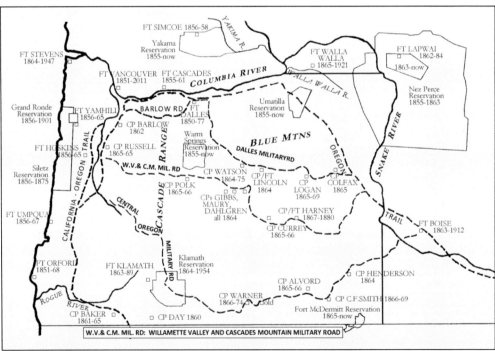

FORTS, CAMPS, ROADS, AND RESERVATIONS. During the period from 1857 to 1871, there was considerable military activity in southeastern Oregon and southern Idaho. The initial purpose was to protect immigrant travelers from marauders (the Snake Indians), and later included protection of miners and settlers. This map shows principal military forts and camps, major military roads built under a federal land grant program, and the region's reservations for treaty tribes.

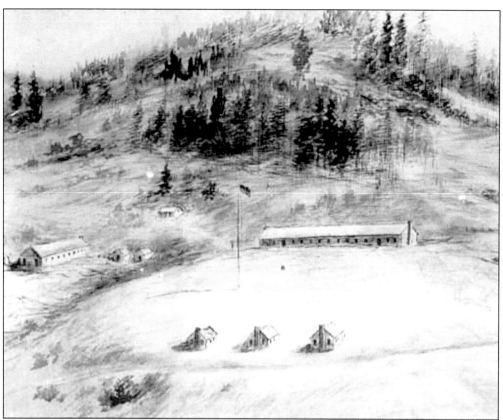

FORT HOSKINS. Established west of the Siletz Reservation for the purpose of controlling and protecting Siletz Reservation Indians, Fort Hoskins existed from 1856 until it was evacuated in 1865. This sketch of the early fort shows southwest-facing officers' quarters in the front, company quarters to the rear, and company stores to the left. Several volunteer units were stationed here during the Civil War years. (OHPC Ben Maxwell Collection 4563.)

PHILIP HENRY SHERIDAN. Lieutenant Sheridan, Fourth US Infantry, served in the Yakima War, located the Fort Hoskins site, and was stationed there and at Fort Yamhill. He was described as a kind and humane mediator in Indian disputes. Promoted to major general, he commanded Union forces in decisive Civil War campaigns, was significant in Plains Indian wars, and became commanding general of the US Army in 1886. (Clipart courtesy FCIT, http://etc.usf.edu/clipart.)

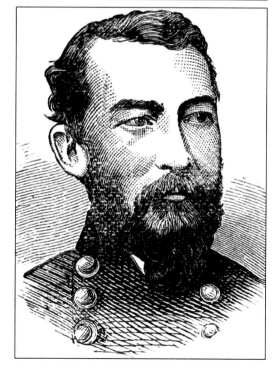

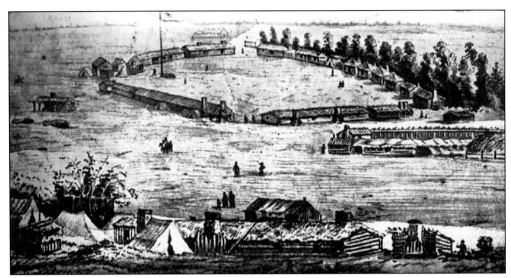

Fort Walla Walla. In August 1856, Col. George Wright, Ninth US Infantry commander, ordered the establishment of a permanent Fort Walla Walla (replacing earlier temporary forts). This post was completed and dedicated on September 19 and was occupied by four companies. The fort remained active until its official abandonment in 1910, with a brief revival during World War I. (Fort Walla Walla Museum.)

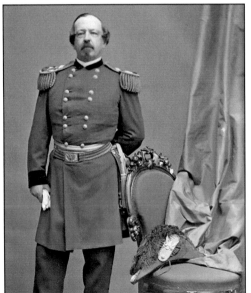

Captain Wallen and Scout McKay. In 1859, Capt. Henry D. Wallen, Fourth US Infantry, led a large expedition from Fort Dalles to the Snake River in an attempt to develop a new wagon road. He completed the route but knew it could not be used by wagons. The next year, Maj. Enoch Steen tried to find a better route. Captain Wallen served in New Mexico during the Civil War and was granted the rank of brevet brigadier general for faithful and meritorious services. Donald McKay served as an interpreter and leader of scouts for Major Steen's expedition and several other operations. He learned to speak French, English, and seven Indian languages. His father was part Cree, and his mother was Cayuse. (Left, National Archives and Records Administration 529235; right, OHS CN 019040.)

BLUE MOUNTAINS GOLD! Prior to 1861, Eastern Oregon was primarily Indian country. In 1861 and 1862, gold was discovered at several locations in the Blue Mountains. Thousands of gold-seekers swarmed into Eastern Oregon, followed by merchants and farmers. These newcomers occupied an important Paiute hunting and gathering area, creating new conflicts. Military forces took on a new mission of protecting miners, settlers, and freight wagon trains. (Carol S. Poppenga painting, OMD.)

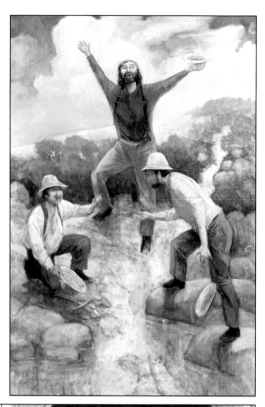

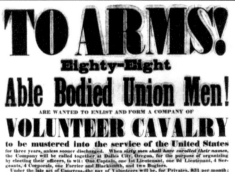

TO ARMS! CAPTAIN CURREY. After the Civil War broke out and most federal troops headed east, Oregon was directed in October 1861 to raise a cavalry regiment. George Currey distributed this poster in Dalles City (The Dalles) and recruited Company E. The regiment's most vigorous company commander, he led his unit through southeast Oregon, southern Idaho, and northern Nevada. In 1865, he was promoted to lieutenant colonel commanding the First Oregon Volunteer Infantry Regiment. (OHS 020568.)

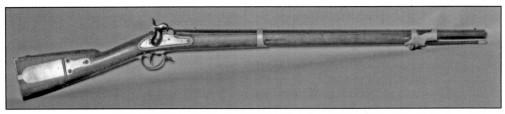
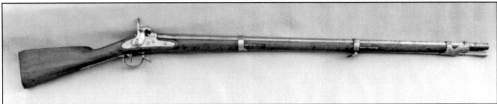

OUT-DATED ARMS. When first organized in 1861, the First Oregon Volunteer Cavalry was armed with weapons in storage at Fort Vancouver. The shoulder arms issued were described as "old-style long guns" and included these two percussion lock muzzleloaders: the .54-caliber Model 1841 rifle and the .69-caliber Model 1842 smoothbore musket. The 56-inch-long musket would have been a particularly cumbersome weapon for horse-mounted troops. (Top, OHS; bottom, OMM.)

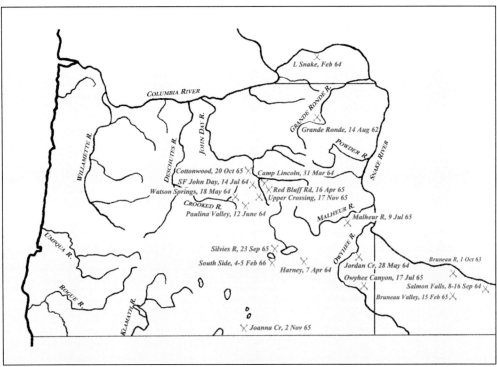

MAJOR ENGAGEMENTS, 1862–1866. During this period, First Oregon Volunteer Cavalry and First Oregon Volunteer Infantry units were mostly engaged in the south Blue Mountains and the upper Great Basin desert areas. Prior to 1862, US Army units engaged hostiles near Harney Lake, Steens Mountain, and the Umatilla River. After 1866, Army units engaged hostiles in southwestern Idaho, Owyhee, Malheur Lake, and Pueblo Mountains areas.

CURREY AND UMHOWLISH. In 1864, Capt. George Currey led an expedition from Fort Walla Walla to protect southeastern Oregon travelers and miners. On the Umatilla Indian Reservation, he recruited Cayuse leader Umhowlish and 10 Cayuse warriors to accompany this expedition. These Cayuse were "agile, brave and intrepid" according to Currey. The expedition covered 2,000 miles, established Camps Henderson and Alvord, and engaged in several skirmishes. (Carol S. Poppenga painting, OMD.)

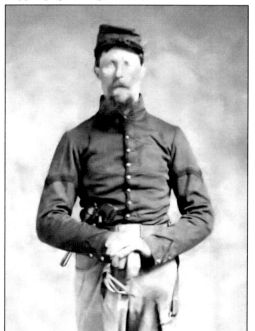 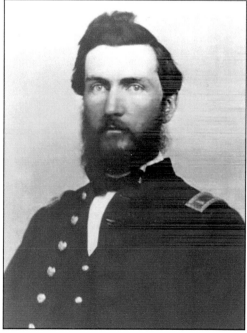

CORPORAL MCKINNEY AND LIEUTENANT HAND. Company G, First Oregon Volunteer Cavalry, mustered in at Fort Vancouver on August 16, 1862. Most of its members were from the Portland area, but Cpl. George W. McKinney was from Jacksonville. It was led by Capt. Henry Small and 1st Lt. William Hand. Company G mustered out June 25, 1866. Hand became editor of The Dalles' *Daily Mountaineer* newspaper. (Left, Christina Chenoweth; right, Wasco County Historical Society.)

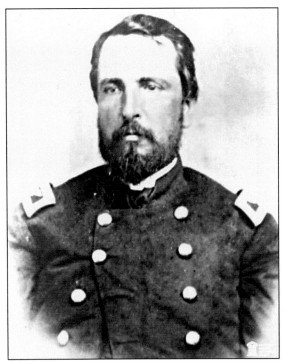

REUBEN F. MAURY. Appointed lieutenant colonel of the First Oregon Volunteer Cavalry, Reuben Maury became regimental commander when Col. Thomas R. Cornelius resigned in July 1862. Promoted to full colonel in April 1865, he served as commander until the regiment mustered out in July 1865. He then returned to southern Oregon and engaged in mining, farming, and raising livestock. Central Oregon's Maury Mountains are named after him. (Southern Oregon Historical Society No. 17065.)

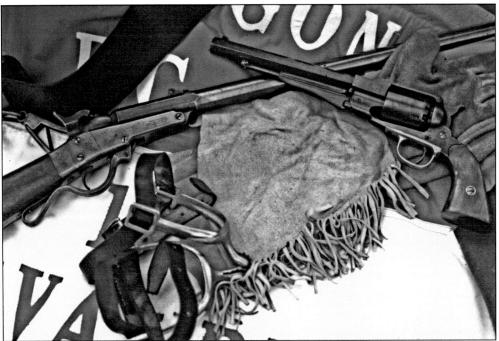

UPDATED CAVALRY ARMS AND ACCOUTREMENTS. By 1864, the First Oregon Volunteer Cavalry was receiving some up-to-date arms. These included the Maynard .50-caliber carbine, a percussion cap brass cartridge breechloader, and the Remington .44-caliber New Model Army revolver, a six-shot percussion cap sidearm. Accoutrements shown are enlisted-grade riding spurs, non-issue gloves, and a carbine shoulder sling, all resting on a cavalry guidon.

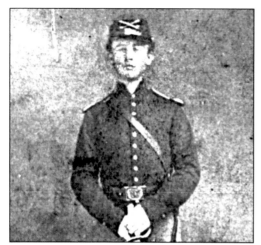

JAMES WAYMIRE AND JOAQUIN MILLER. Enlisting as a private in Company B, First Oregon Volunteer Cavalry, in December 1861, James Waymire was promoted to second lieutenant in April 1863. He led expeditions into southern Idaho and Harney Valley in Oregon and established Camp Lincoln. He later served as private secretary to Oregon governor Addison Gibbs, studied law, moved to California, and was elected judge of the California Superior Court. Joaquin Miller was a John Day Valley resident in the 1860s and commanded the 1864 company of Canyon City volunteers. His family moved from Indiana to Oregon in 1852. Joaquin went to the California gold mines, attended college in Eugene, rode for the Pony Express in Idaho, became a newspaper editor, and lived in many places. He is best known for his poetry. (Left, OHS 020569; right, Lee Morehouse photograph, c. 1900, OHS 002884.)

HARNEY VALLEY PATROL. In April 1864, Lieutenant Waymire's Oregon Cavalry detachment and 30 Canyon City volunteers pursued a Paiute party to the base of Steens Mountain. On April 7, a four-man patrol was dispatched to investigate a large smoke arising three miles away. Then a combined Paiute force routed the detachment and volunteers. The patrol was not seen again and was presumed killed. (Don Gray painting, OMD.)

STOCK WHITLEY (STOCK-OTE-LY). In 1864, Stock Whitley led 21 Warm Springs scouts accompanying a First Oregon Volunteer Cavalry expedition under Capt. John Drake. On May 18, they surprised and attacked a Paiute camp on the upper Crooked River. Lt. Stephen Watson, two privates, and a Warm Springs scout were killed, and Stock Whitley was mortally wounded. Captain Drake wrote that Stock Whitley was a "perfect old hero." (Sohon sketch, WSHS.)

CAMP WATSON. This site on the road from Fort Dalles to Canyon City was selected in October 1864 and named to honor Lt. Stephen Watson, killed in action on the nearby upper Crooked River. Members of Company G, First Oregon Volunteer Cavalry, built its log huts and operated out of this post until mustered out in May 1866. Federal troops used Camp Watson for several more years. (OHS 1661.)

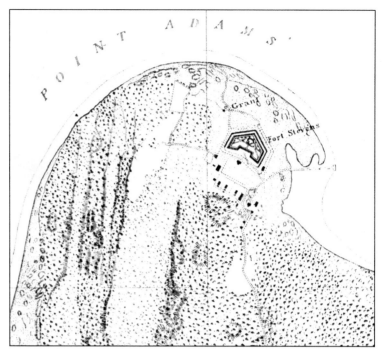

FORT STEVENS. The Confederate navy had a cruiser operating in the Pacific, but this was not the only perceived threat to the US West Coast. There were potentially hostile ships at a British naval base in nearby Victoria, Canada. Consequently, Fort Stevens was constructed in 1863–1864 at the Columbia River mouth. It was a walled redoubt surrounded by a moat with muzzle-loading guns of 8-, 10-, and 15-inch caliber. (OHS.)

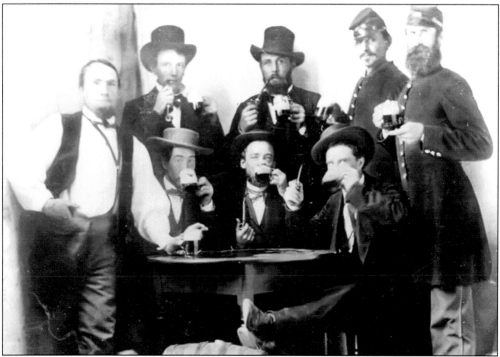

ENJOYING PIPES AND BEER. Service wasn't always stern. This party of eight includes Col. Reuben F. Maury (center back) with Lt. Frank B. White and Lt. D.C. Underwood on his left. Colonel Maury commanded the First Oregon Volunteer Cavalry Regiment. Lieutenant White was assigned to the regiment's Company E and later promoted to captain in command of Company B. Lieutenant Underwood was assigned to Company C. (OHS 21090.)

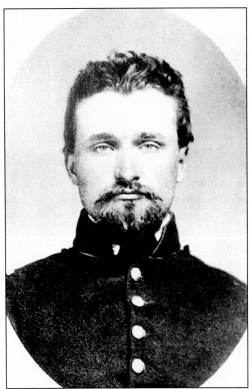

CUSICK AND HILLEARY. In December 1864, schoolteachers William Cusick and William Hilleary enlisted in Albany as members of Company F, First Oregon Volunteer Infantry. Cusick was soon promoted to sergeant, and Hilleary became a corporal. Company F marched to Fort Hoskins, then to Fort Vancouver, to Fort Walla Walla, to Camas Prairie, and to Fort Lapwai, Idaho. In late 1865, the unit built Camp Colfax in southeast Oregon. After they mustered out in July 1866, Cusick moved to a ranch, where he began collecting botanical specimens; 27 Oregon-native plant species are named after him. Hilleary went back to teaching school, became master of the State Grange, and was appointed to the Oregon Agricultural College Board of Regents. (Left, Sylva Missildine; right, UofO.)

PAULINA. From 1860 to 1867, Paulina and his followers covered a large area and were blamed for killings and livestock thefts in John Day country. In 1867, Paulina was killed by rancher Howard Maupin. Eight geographic features were named after Paulina; the town Maupin was named after the rancher. (OHS 11494.)

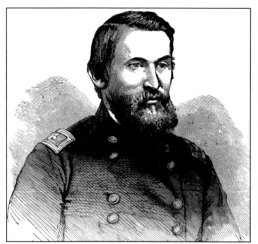

GEORGE CROOK AND WILLIAM MCKAY. Distinguished Civil War leader Lt. Col. George Crook arrived at Fort Boise late in 1866 as the Army's new district commander. Under his leadership, troops engaged in winter operations in southeast Oregon and established a winter headquarters at Camp Warner. In 1868, Paiute leader Egan was captured and Malheur and Warner Lake Paiute surrendered, essentially ending hostilities in the region. Later, Crook led campaigns in the Great Sioux War and Apache Wars and was promoted to major general. Dr. McKay was appointed commander of a company of Warm Springs scouts raised in 1866. They served under Crook. Sponsored by his step-grandfather Dr. John McLoughlin and by missionary Dr. Marcus Whitman, the mixed-blood McKay completed a medical degree at age 19. After 1868, he served as a physician in the Pendleton area. (Left, Clipart courtesy FCIT, http://etc.usf.edu/clipart; right, OHS OrHi 653.)

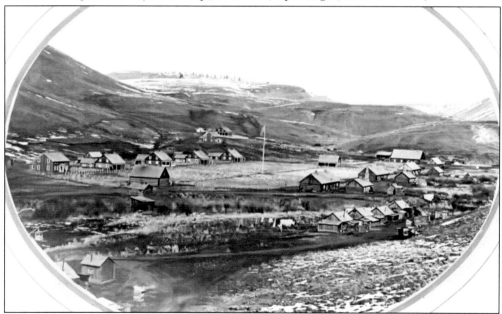

FORT HARNEY. In 1867, Lt. Col. George Crook established Camp Steele as an operations base for the Malheur and Steens section of southeast Oregon. It was soon renamed Fort Harney to honor Brig. Gen. William Harney, Department of Oregon commander from 1858 to 1860. On a 640-acre reserve, it was located on Rattlesnake Creek about two miles northeast of the current community of Harney. The post was abandoned in 1889. (OHS OrHi 80035.)

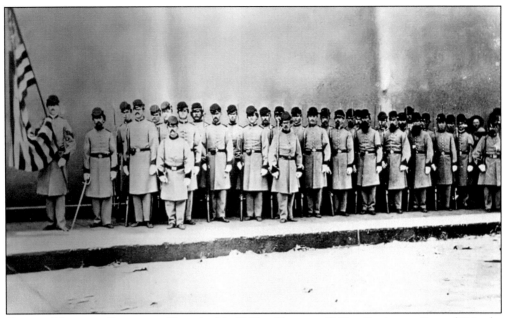

OREGON MILITIA IN PORTLAND. Organized in 1863 as Company B, First Regiment, Second Brigade, this was one of the first Oregon Militia units. It was called the "Washington Guards;" several militia units adopted special titles such as this. The Oregon Militia was defunded in 1870, but this unit, redesignated as Company A, continued to function at its own members' expense until the new Oregon National Guard was organized in 1887. (OHS OrHi 81816-A.)

OREGON MILITIA OFFICERS. The officers of Company A, First Regiment, First Brigade, Oregon Militia, were Lt. Wilborn Beeson, Lt. Linus Walker, and Capt. Abel D. Helman. Company A, the "Mountain Rangers" of Ashland Mills (now Ashland), was organized in 1864 as a unit of 71 mounted cavalry troops. Capt. Oliver Applegate was their first commander. Helman was elected commander in 1866. Company A disbanded in 1867. (Talent Historical Society.)

Four
LATE INDIAN WARS
1872–1880

During this period, there were three major conflicts: the 1872–1873 Modoc War, which ranged from south-central Oregon into Northern California; the 1877 Nez Perce War, in which Oregon warriors were pursued through Idaho into central Montana; and the 1878 Bannock-Paiute War, which ranged from southwest Idaho into northeast Oregon.

Army units in the Pacific Northwest during this period included elements of the Twelfth and Twenty-First Infantry Regiments, Fourth Artillery Regiment, and First Cavalry Regiment. Military facilities in and near Oregon included Fort Dalles, Fort Stevens, Fort Klamath, and Fort Harney in Oregon; Fort Vancouver and Fort Walla Walla in southern Washington; Fort Lapwai and Fort Boise in Idaho; Fort McDermitt in Nevada; and Camp (Fort) Bidwell and Fort Jones in Northern California.

Oregon and California volunteer units and Klamath and Warm Springs scouts participated in the Modoc War. In 1873, at least one volunteer company started to organize in northeast Oregon. During the Nez Perce War, a few local units temporarily organized in northeast Oregon, but the conflict never entered the state. In response to the Bannock-Paiute attack, in June and July 1878, nine units of Oregon Volunteers organized and served in northeast Oregon from 8 to 52 days. Indian scouts and volunteers engaged the Bannock-Paiute directly in battles, and one group in effect ended the war.

On the ground, news coverage of these conflicts became popular. Telegraphed reports quickly reached publications such as *Harper's Weekly*, with field sketches and photographs following a few weeks later.

A US Life-Saving Service station was established on Coos Bay in 1878.

The Oregon Militia was practically nonexistent early in this period—in 1871, only four companies were listed as organized units. All four were in Portland. In 1879, there were 19 companies listed with locations throughout the state.

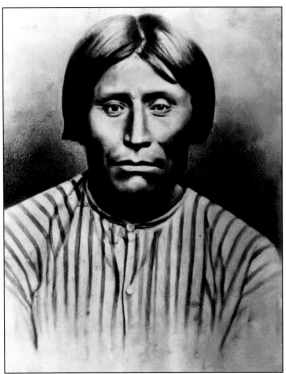

CAPTAIN JACK, KINTPUASH. Leader of the Lost River Modoc, Captain Jack and his band were forced onto the Klamath Reservation in late 1869. Mistreated by their Klamath rivals, they left the reservation in April 1870 and met with Klamath agent John Meacham, who said they could remain in their Lost River home for a while. Meacham was replaced, and an Army unit arrived in March 1872 to force the band back onto the reservation. (OHS 4357.)

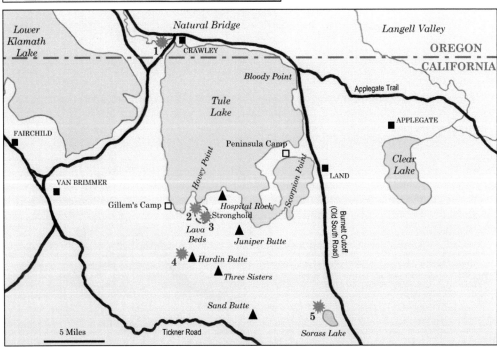

1872–1873 MODOC WAR SITES. Included on this map are: 1. Battle at Lost River, November 29–30; 2. First Battle of the Stronghold, January 17; 3. Second Battle of the Stronghold, April 15–17; 4. Battle at Hardin Butte, April 26; and 5. Battle at Sorass Lake, May 10. Other locations include the Applegate, Crawley, and Van Brimmer ranches, which were involved in the war.

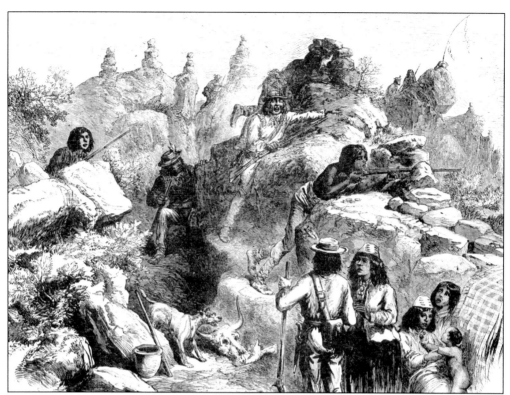

IN THE STRONGHOLD. On November 29–30, Captain Jack and his band skirmished with Cavalry Troop B at Lost River, then went south into the Lava Beds Stronghold. Hooker Jim's Modoc band joined them there. On January 17, these 60 warriors in their natural fortress repelled an attack by 300 soldiers, then picked up the guns and ammunition left on the battlefield by the retreating soldiers.

EDWARD R.S. CANBY. Veteran of the Seminole, Mexican, and Civil Wars, Canby was promoted to brigadier general and appointed commander of the Department of Columbia in 1870. Brigadier General Canby became part of a peace commission appointed by US secretary of the interior Columbus Delano in January 1873. He parleyed with Modoc leaders including Captain Jack, then was assassinated at the April 11 meeting, the only general killed in America's Indian wars.

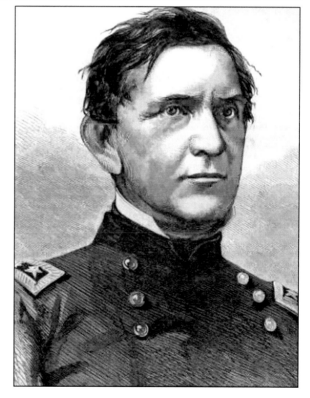

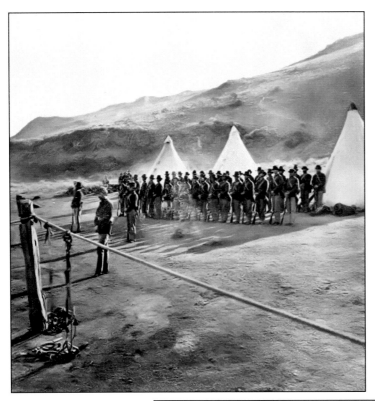

TROOPS AT GILLEM'S CAMP. On April 1, Brig. Gen. Edward Canby and Col. Alvan C. Gillem moved the entire force to this camp at the base of a bluff on the edge of the Lava Beds. This force included 18 companies and detachments of the Army's Twelfth Infantry, Twenty-first Infantry, Fourth Artillery, and First Cavalry Regiments, as well as 70 Warm Springs scouts and three companies of Oregon Mounted Militia. (OHS CN 016807.)

GROUP PHOTOGRAPH. Standing from left to right are Oliver Applegate, Toby Riddle (Nan-Ook-To-Wa, Winema) and her husband Frank Riddle. Applegate organized and commanded Company B, First Brigade, Oregon Mounted Militia, which participated in the first Stronghold battle. Modoc Toby Riddle was a messenger and interpreter during the Modoc War, helped set up the peace conference, and warned the peace commission of danger at the April 11 meeting. (OHS OrHi 12715.)

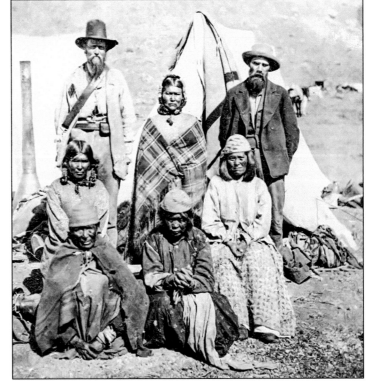

DONALD MCKAY. Serving as a scout throughout the Modoc War, McKay led a company of scouts from the Warm Springs Reservation. After the war, he took a "Wild West" medicine show on tour through the eastern United States and Europe. He then became an interpreter on the Umatilla Indian Reservation. His 1899 obituary described him as "intrepid and fearless . . . a rare prize indeed for the early commanders of federal troops."

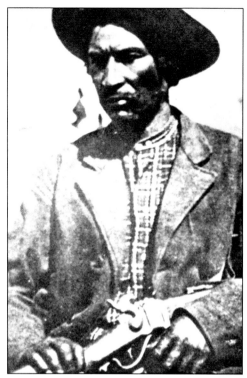

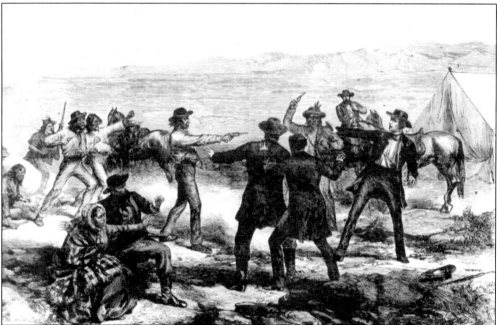

ASSASSINATIONS. After parlaying with the peace commission, Captain Jack and 11 others spoke for peace in a Modoc council. Ridiculed and taunted with "You are a fish-hearted woman!", Captain Jack was overruled, and the council decided to kill the peace commissioners. In the April 11 peace meeting, Captain Jack assassinated Brig. Gen. Edward Canby. Rev. Eleasar Thomas was also killed, and Alfred B. Meacham was wounded but saved by Toby Riddle.

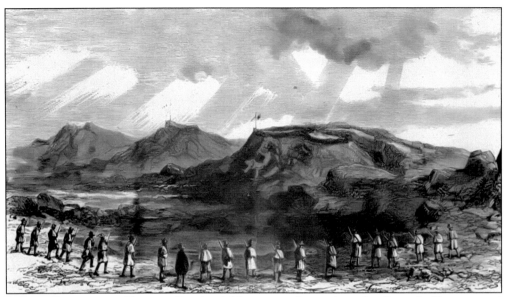

SECOND STRONGHOLD BATTLE. On April 15, troops advanced on the Stronghold, supported by artillery and mortar fire. The next day, forces joined from the north, cutting the Modoc off from their water supply. On April 17, the Modoc evacuated the Stronghold and retreated south. They became engaged in two more battles, then began surrendering. On June 1, Captain Jack surrendered on the upper Lost River near Clear Lake.

LOA-KUM-AR-HUK, WARM SPRINGS SCOUT. Seventy-two volunteer scouts from the Warm Springs Reservation arrived on April 13. They were issued modern arms such as the Spencer Model 1865 repeater pictured here. After the Second Stronghold Battle, they patrolled south into the Lava Beds, searched for the retreating Modoc, participated in the May 10 battle at Sorass Lake, and assisted in capturing the last of the retreating Modoc. (National Archives and Records Administration.)

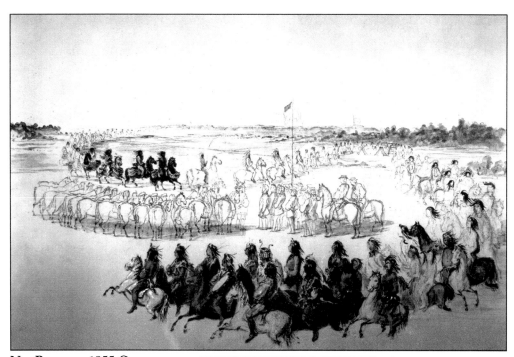

NEZ PERCE AT 1855 COUNCIL. The Nez Perce (Nimi'ipuu) displayed in review before attending the Walla Walla treaty council. They mostly agreed to a treaty that left them a large parcel in what is now northeast Oregon, southeast Washington, and central Idaho. In 1863, a new treaty council acted to drastically reduce their lands. Several chiefs, including Old Chief Joseph, walked out and became "non-treaty" Nez Perce. (NAA 5734.)

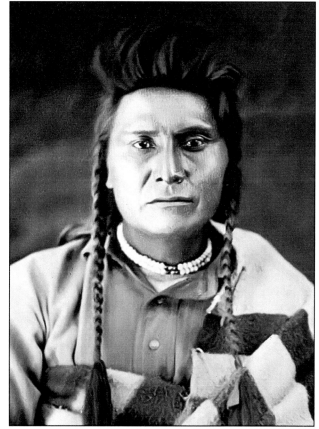

YOUNG CHIEF JOSEPH, HEINMOOT TOOYALAKEKT. The Wallowa Nez Perce never accepted the 1863 treaty. Young Chief Joseph, as one of their leaders, continued to befriend Wallowa Valley settlers and government officials. He also looked for a way for his people to remain in the Wallowas. Old Chief Joseph died in 1871, exhorting his son to never abandon their ancestral homeland. (NAA 2905A-2.)

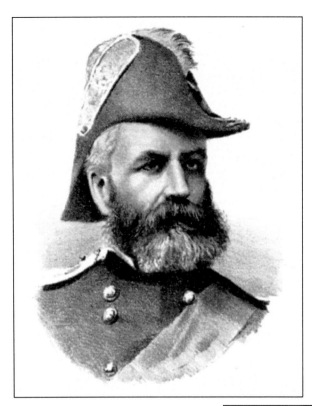

OLIVER HOWARD. In 1876, the Army told non-treaty Nez Perce that they must move onto the 1863 reservation. In early May 1877, Department of the Columbia commander Brig. Gen. Oliver Howard gave them 30 days to make this move. Chief Joseph asked for more time so they could avoid crossing the Snake and Salmon Rivers during spring runoff. This was not granted, so considerable livestock and possessions were lost crossing the Snake River. (OHS ENV520)

LOOKINGGLASS, APPUSHWA-HITE. Some non-treaty Nez Perce preferred to settle on the reservation, some pushed for a fight, and some wanted to escape into Canada. On June 14, violence broke out with antagonistic settlers on the Salmon River, and the Nez Perce War started. Lookingglass, one of the non-treaty band leaders, became a principal leader during the war. He was killed on October 5, the final day of the last battle at Bear's Paw. (NAA 2935A.)

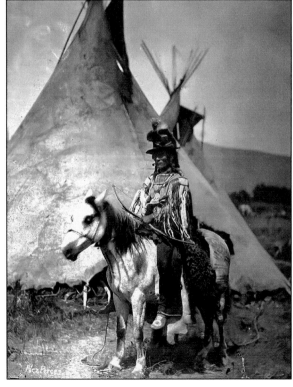

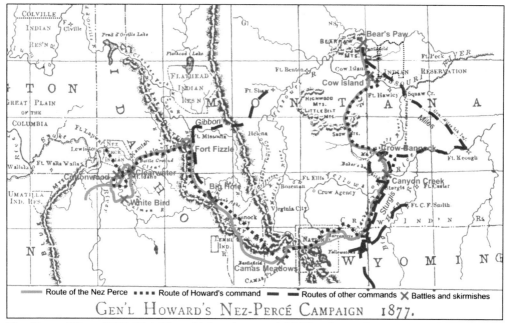

NEZ PERCE WAR, 1877. Chief Joseph's band covered 1,200 miles in their attempted escape into Canada. They fought the Battle of White Bird on June 17, the Cottonwood Fight on July 4–5, the Battle of the Clearwater on July 11–12, the Fort Fizzle Barricade on July 25–29, the Battle of Big Hole on August 9, the Camas Meadows Raid on August 19–20, the Canyon Creek Skirmish on September 13, the Crow-Bannock Skirmishes on September 14–17, the Cow Island Skirmish on September 23–24, and the Bear's Paw Battle and Surrender from September 30 to October 5.

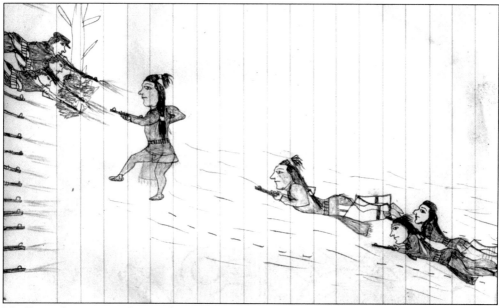

NEZ PERCE SKETCHBOOK BATTLE SCENE. Army troops fire on Nez Perce warriors in a sketch probably based on a personal recollection. This is from a c. 1900 sketchbook found in an Umatilla Indian Reservation house demolished in the 1970s. It depicts the strength ratio of this war, where about 1,400 regulars and civilian volunteers pursued and battled with about 250 Nez Perce warriors. (UofO.)

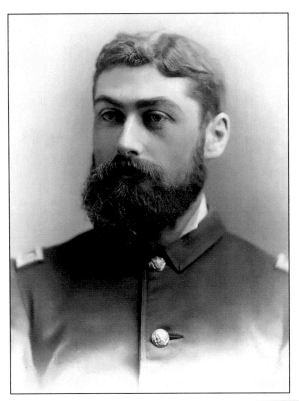

CHARLES ERSKINE SCOTT WOOD. As aide to Brigadier General Howard, First Lieutenant Wood chronicled Chief Joseph's famous surrender speech, which ended with: "Hear me, my chiefs! I am tired. My heart is sick and sad. From where the sun now stands I will fight no more forever." Wood became a prominent attorney in Portland and a permanent friend of Joseph. (US Military Academy Library, Special Collections and Archives.)

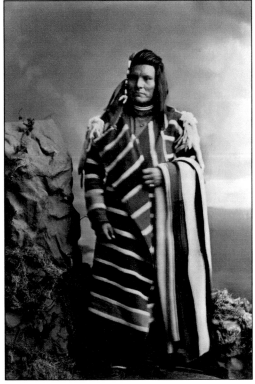

YELLOW BULL, TSUTLILM-MOXMOX. Leader of the Lamtama Nez Perce from Idaho, Yellow Bull surrendered with Joseph. Contrary to Brigadier General Howard's terms for surrender, these Nez Perce were exiled to Oklahoma's Indian Territory, where many died. Yellow Bull, Joseph, C.E.S. Wood, and others met with Pres. Rutherford Hayes to campaign for resettlement in Idaho. In 1885, the 150 surviving Nez Perce were sent to Washington's Colville Reservation. (NAA 2952-C.)

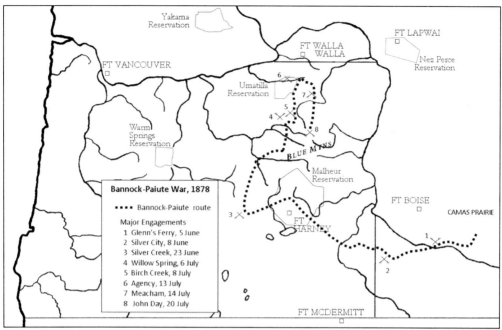

BANNOCK-PAIUTE WAR, 1878. Idaho's Camas Prairie was an important source of root food. In the spring of 1878, it was overtaken by 2,500 head of settlers' cattle, destroying this Bannock resource. Led by Chief Buffalo Horn, the Bannock decided to go to war. A Paiute band led by Chief Egan allied with them. They headed toward Oregon with a goal of eventually allying with warriors on the Umatilla and Yakama Reservations.

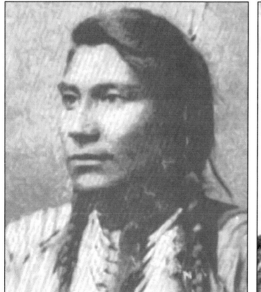
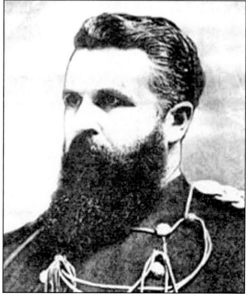

BUFFALO HORN AND REUBEN BERNARD. Chief Buffalo Horn led the Bannock-Paiute war party until he was killed in the Silver City Battle. Paiute chief Egan then became their leader. Capt. Reuben Bernard led 220 cavalry troops pursuing this war party of about 800, surprising them on June 23 at Silver Creek and forcing them to escape north. The war party skirmished with settlers as they headed towards the Columbia River.

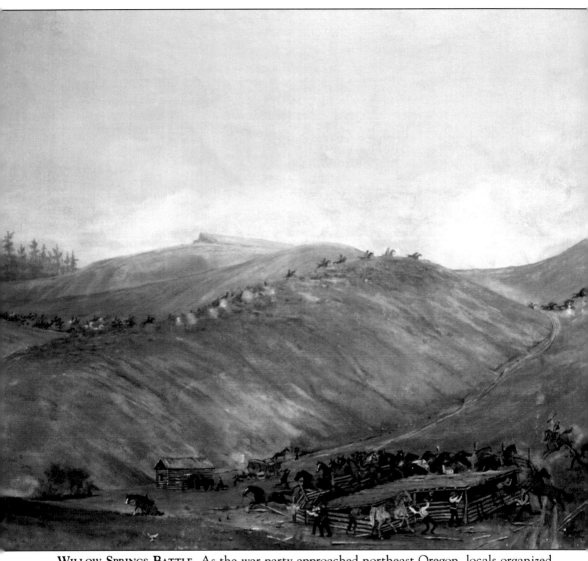

WILLOW SPRINGS BATTLE. As the war party approached northeast Oregon, locals organized volunteer units, and the state equipped them with arms. County sheriff John Sperry organized the 45-member Umatilla County Guards and led it toward the approaching war party. On July 6, while eating lunch at Willow Springs south of Pilot Rock, they were attached by over 100 warriors. They fought until dark, then conducted a fighting retreat. Two volunteers were killed. (Morrow County Museum.)

BIRCH CREEK BATTLE. On July 8, Captain Bernard and his seven companies of cavalry caught up with the war party at Birch Creek and drove them off. Other units were in front of the war party, which then fled into the forest. They tried to attack the Umatilla Agency on July 13 but were beaten back by a large military force including some volunteer units.

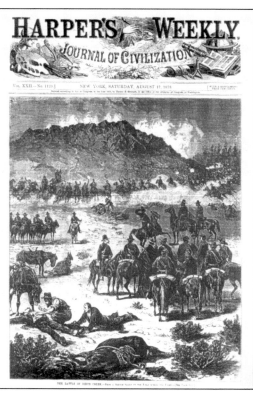

WAR CHIEF UMAPINE (CENTER FRONT). On July 15, a cavalry unit skirmished with the retreating Bannock-Paiute war party near Meacham's Station. A party from the Umatilla Reservation led by Chief Umapine tracked down and killed Chief Egan. Another brief skirmish occurred on July 20 on the John Day River headwaters. Surviving members of the war party scattered east or surrendered, ending the last of Oregon's Indian wars. (OHS OrHi 9526.)

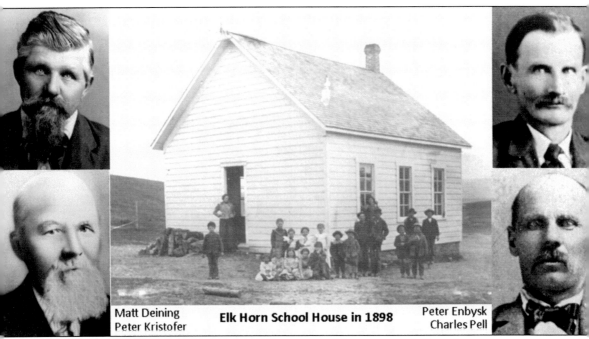

Matt Deining
Peter Kristofer
Elk Horn School House in 1898
Peter Enbysk
Charles Pell

WILD HORSE RANGERS. In December 1878, a group of farmers, mostly Finnish immigrants, met at Elk Horn School House near Wildhorse Creek in Umatilla County and organized Company B, Third Brigade, Oregon Militia. They named themselves the Wild Horse Rangers and served as a drilling unit for two years. They performed one civil support function, providing security and patrols when two local Indians were hanged in early 1879 for murdering a teamster.

Five

NATIONAL GUARD AND THE PHILIPPINES
1881–1899

This period featured the creation of the Oregon National Guard, state activations for civil support duty, activation for federal service in the Philippines during the Spanish-American War and ensuing Philippine Insurrection, and creation of a separate Oregon Naval Militia battalion.

The Indian wars in Oregon were over, so the number of Army posts and units in the Pacific Northwest declined. Army forts in and near Oregon during this period included Fort Klamath (vacated 1889) and Fort Stevens in Oregon, Fort Vancouver and Fort Walla Walla in southern Washington, Fort Lapwai and Fort Boise in Idaho, Fort McDermitt in northern Nevada (turned over to the Indian Service in 1889), and Fort Bidwell (vacated 1893) and Fort Jones in Northern California.

During this period, the US Life-Saving Service established new stations at Bandon (1890), Warrenton (1889), Winchester Bay (1891), and Newport (1895).

In 1882, the Oregon Militia had 20 listed companies with locations throughout the state (some of these units existed only on paper). By 1884, this declined to 10 listed companies. In 1887, the state legislature created and funded the Oregon National Guard. By 1889, there were three organized infantry regiments with nine line companies each, plus a separate battery of artillery and troop of cavalry (a total of 29 company-sized units with a total strength of 1,702). The 1887 Militia Law required counties to also maintain a list of all persons "who are liable to do military duty." There were 58,896 names on the 1897 lists.

Oregon National Guard field-training camps of instruction were held for most units in 1891, 1892, 1893, and 1897. State units were called out five times during this period for civil support duty to help quell riots and prevent lynchings.

In May 1898, most of the Oregon National Guard was mustered into federal service as the Second Oregon US Volunteer Infantry for duty in the Philippines. There they first received the Spanish army's surrender and occupied the city of Manila, then battled Philippine Insurrectionists for five months. Three members of the Second Oregon and one Oregon member of the US Volunteer Signal Corps were awarded Congressional Medals of Honor.

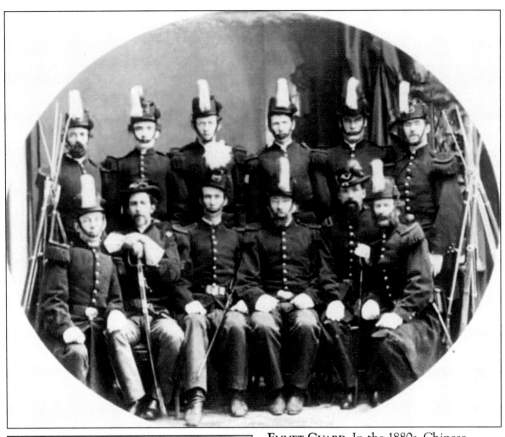

EMMET GUARD. In the 1880s, Chinese immigrants who had been working on railroads and mines started entering the general labor pool. Because of job shortages, anti-Chinese agitation resulted in rioting on the West Coast. In February 1886, several Oregon Militia units were mobilized to quell violence in Portland. The Emmet Guard (Company B, First Regiment, Second Brigade), a mostly Irish unit, was disbanded for refusing this duty. (OMM.)

OWEN SUMMERS. The 1887 Militia Law creating the Oregon National Guard was named the "Summers Law" after the legislator who sponsored it. Besides serving in the Oregon legislature, Owen Summers was a regimental adjutant in the old Oregon Militia and became a lieutenant colonel in the new Oregon National Guard. Unlike the poorly funded Oregon Militia, the new Oregon National Guard and its adjutant general's office were adequately funded. (OMM.)

MULTNOMAH COUNTY ARMORY, 1888. Constructed in downtown Portland by Multnomah County, this castellated building was the first formal government-built National Guard armory in Oregon. An annex added in 1891 provided an indoor rifle range and a large drill hall. This large space housed a number of important public events. The original armory was demolished in 1968, but the annex is now a stage theater. (OHS photo file no. 1759.)

CHARLES MORGAN. On May 9, 1889, the Wasco County sheriff learned of a plan to lynch a Chinese man in county custody. The sheriff needed jail guards and notified Colonel Morgan, commander of Oregon National Guard's Third Regiment, who immediately called out 22 members of Company C in The Dalles. The lynching was prevented, and the man in custody was discharged the next day as innocent. (Wasco County Historical Society.)

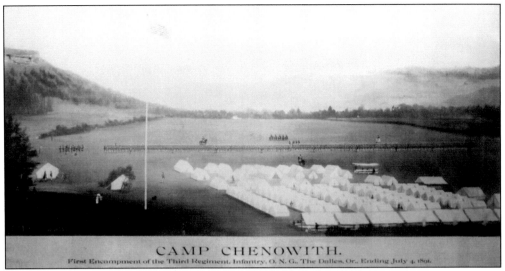

CAMP CHENOWITH. The Oregon National Guard held its first field training encampments in 1891. The Third Infantry Regiment, with units in central and Eastern Oregon, encamped June 28 to July 4 at temporary Camp Chenowith, located 2.5 miles west of The Dalles. This drawing shows the entire regiment in a line formation just beyond the tent city. The other two regiments encamped near St. Helens and Eugene. (Wasco County Historical Society.)

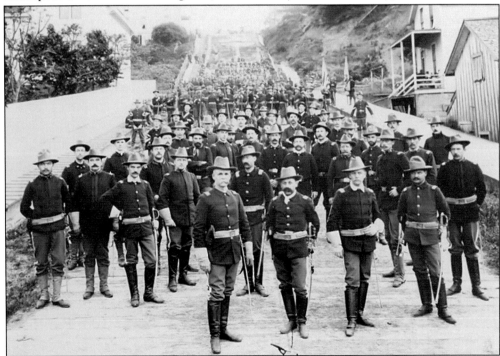

ASTORIA FISHERMEN'S STRIKE, 1896. A price dispute with salmon canneries resulted in a strike by the fishermen's union. Violence resulted that local authorities could not handle. Oregon's governor acted to send in Oregon National Guard's First Infantry Regiment from Portland. They served from June 16 to 22 under the command of Col. Owen Summers and brought about the termination of the strike without loss of life or property. (Clatsop County Historical Society.)

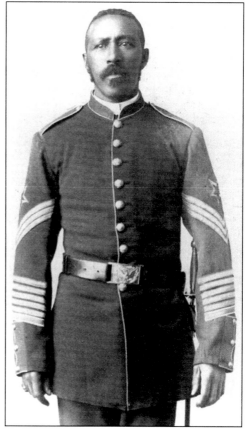

MOSES WILLIAMS. This photograph is emblematic of ordnance sergeant Moses Williams, commander at Fort Stevens from 1895 to 1898. Enlisting in 1866 and serving in the all-black Ninth US Cavalry, he was awarded the Congressional Medal of Honor for "coolness, bravery, and unflinching devotion to duty" during an 1881 engagement with Apache in New Mexico. He died in 1899 and is buried at Vancouver Barracks Post Cemetery. (National Archives and Records Administration.)

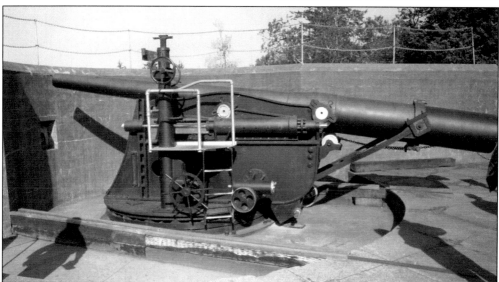

FORT STEVENS REFORTIFICATION. In 1897, a nationwide program began improving coastal and harbor defenses. Eight concrete batteries were constructed at Fort Stevens for mortars and long- and short-range rifles, including this 10-inch rifle battery. Fort Stevens was one of three forts at the mouth of the Columbia River. Forts Canby and Columbia were built on the Washington side.

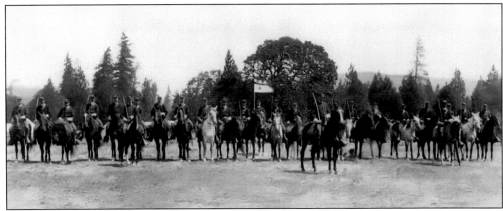

CAVALRY TROOP B, CAMP JACKSON. Troop B was the first National Guard unit organized in Gresham. In 1897, most of Oregon's National Guard units attended a camp of instruction from June 29 into July near Hood River. Adj. Gen. Benjamin B. Tuttle reported that Oregon's officers and men rapidly improved at Camp Jackson, resulting in "the increased efficiency of its troops—soon to be tested on a wider field of action." (OMM.)

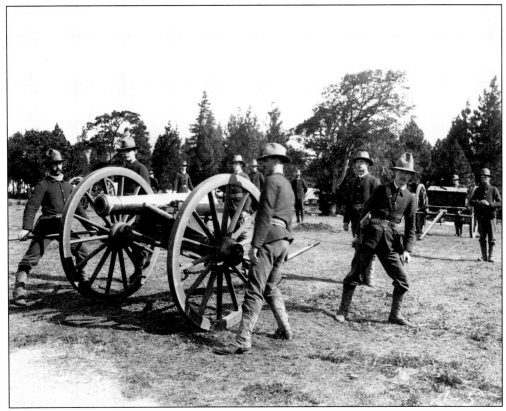

ARTILLERY BATTERY A, CAMP JACKSON. In 1897, Portland's Artillery Battery A trained on its howitzers at Camp Jackson. This temporary camp was named to honor retiring US Army lieutenant colonel James Jackson, who had been assigned to the Oregon National Guard since 1892 as an inspector and advisor. After retiring from the Army, he was appointed inspector general in the Oregon National Guard and promoted to colonel. (Howdyshell Photos.)

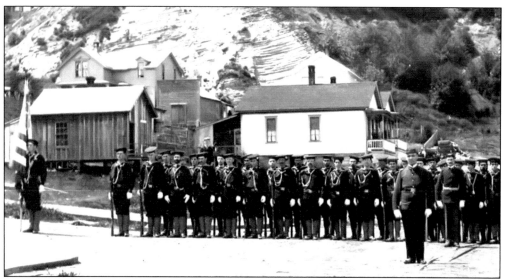

OREGON NAVAL MILITIA. In early 1898, relations between Spain and the United States became strained, and the battleship *Maine* was blown up in Havana Harbor. War seemed imminent, so in April, Oregon decided to organize a battalion of Oregon Naval Militia with two companies in Portland and one company in Astoria (total strength about 129). (OHS OrHi 36630.)

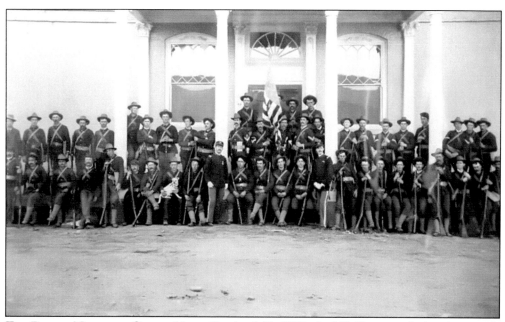

THE DALLES NATIONAL GUARD UNIT. On April 21, 1898, the US Congress declared war with Spain. On April 25, the president set a federal service quota for Oregon of one infantry regiment. Company G, Third Infantry Battalion, assembled at the armory in The Dalles and on April 30 gathered with the other Oregon National Guard infantry units at Camp McKinley in Portland. (Wasco County Historical Society.)

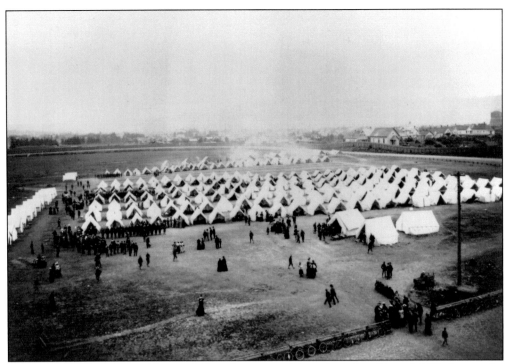

CAMP MCKINLEY. Oregon National Guard units quickly gathered at Camp McKinley on the Irvington Park Racetrack in northeast Portland. Here they consolidated companies, and by May 15, 1898, mustered in as the Second Oregon US Volunteer Infantry Regiment. The regiment proceeded to the Presidio at San Francisco, where they, along with volunteer units from several other states, prepared for departure to the Philippines. (OHS 72824.)

HEADING FOR THE PHILIPPINES. On May 25, the Second Oregon, First California, and part of the Fourteenth US Infantry set sail from San Francisco as part of the first ground force contingent to leave the United States. On June 20, the convoy stopped at Guam, where two Oregon companies disembarked and helped effect the peaceful surrender of this Spanish-controlled territory.

ARTILLERY LIGHT BATTERY B. Responding to a second call for troops, Light Battery A mustered into federal service on July 1 and went to Vancouver Barracks. Light Battery B mustered in on July 29, 1898, and encamped near Sellwood. The units engaged in field training and helped extinguish a nearby forest fire. After a peace protocol was signed with Spain, these batteries mustered out on October 15 and 20, respectively.

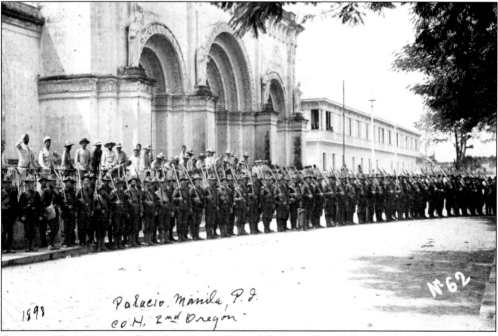

COMPANY H IN MANILA. On July 1–2, the Second Oregon disembarked at Cavite, the first unit to land in the Philippines. It took over control of most of the island of Luzon, then on August 13 became the first force to enter the walled city of Manila. The Spanish forces soon surrendered, and authority over the Philippines passed to the United States. The soldiers then served on Luzon for six quiet months and helped form a provisional government.

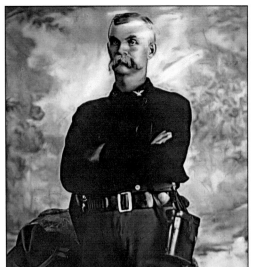 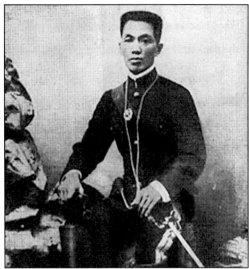

OWEN SUMMERS AND EMILIO AGUINALDO. Commander of the Second Oregon, Colonel Summers was commended for his "energy, judgment, and courage" by H.W. Lawton, major general of volunteers, on June 12, 1899. For this successful leadership, Colonel Summers was honored with a brevet promotion to brigadier general of volunteers. Aguinaldo was a leader in the 1896–1897 Philippine revolution against the Spanish. He had several victories until agreeing to an amnesty and going into voluntary exile in Hong Kong. In May 1898, the Americans brought Aguinaldo out of exile. He assumed command of the revolutionary forces and allied with the Americans in hopes of acquiring Philippine independence. This did not happen, so he led fighting against the occupying Americans. He was captured in 1901, retired into private life, and was 77 when the United States finally recognized Philippine independence in 1946. (Both, OMD.)

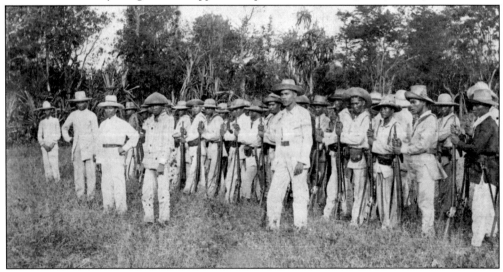

PHILIPPINE SOLDIERS, 1899. A Philippine revolution started in 1896 to gain independence from Spanish rule. It had some early victories, then stalled. In 1898, these insurgents allied with the United States against Spain and declared Philippine independence in June. American leaders did not recognize this and established the US Military Government of the Philippines in August 1898. On February 4, 1899, the insurgents declared war on the occupying US forces. (OHS OrHi 93777.)

SECOND OREGON, 1899. On February 4–5, Philippine insurgents attacked US troops at Manila. The Second Oregon then engaged in these campaigns (and battles): Pasig Campaign, March 13–19 (Pasig and Taguig); Malolos Campaign, March 24–April 21 (Caloocan, Malabon, Bocane, and Marilao); Santa Maria Campaign, April 12–13; San Isidro Campaign, April 22–May 25 (Norzagaray, Angat, San Rafael, San Idelfonso, San Miguel, Tarbon Bridge, San Isidro, and Mount Arayat); and the Morong Expedition, June 2–6 (Taytay and Morong).

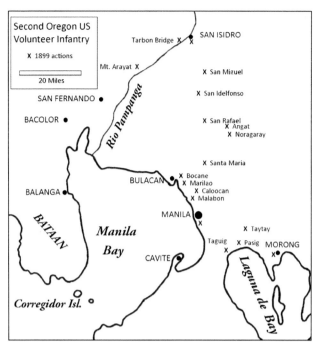

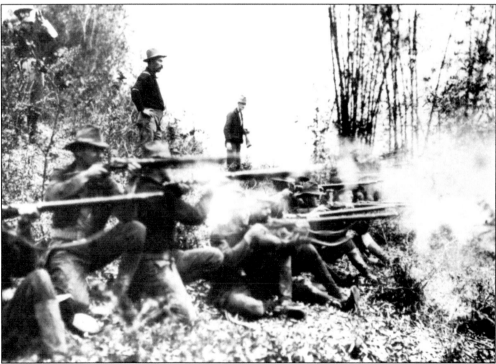

BATTLE OF PASIG, MARCH 14–15. Members of Company L, Second Oregon, are pictured near the market town of Pasig. Oregon troops were still using obsolete single-shot Springfield rifles that produced visible clouds of black-powder smoke. Oregon volunteers were soon issued .30-caliber smokeless-powder Krag-Jorgensen repeaters (Models 1896 and 1898). (US Army Museum photo no. 7218.)

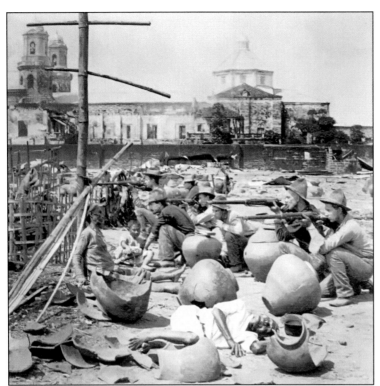

STREET FIGHTING IN MALABON. An early primary objective was seizing the city of Malolos, headquarters of the provisional Philippine government. Most of the Second Oregon participated in this campaign. On the way to Malolos, street fighting took place in Malabon on March 26, 1899. This was the Oregon volunteers' most costly campaign, with 12 members killed or missing in action. (OHS OrHi 23983.)

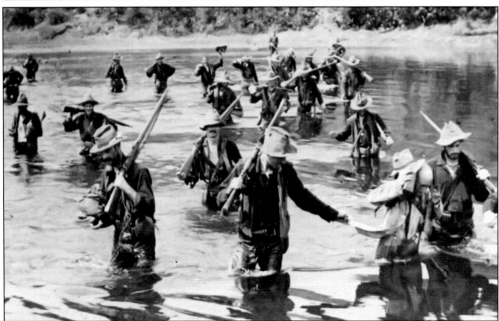

OREGON GREYHOUNDS. The Second Oregon pursued insurgents for many cross-country miles. On March 25, Brig. Gen. Lloyd Wheaton, commander of the volunteer brigade, was asked "where are your regulars?" Pointing to the Oregon volunteers, he replied "There are my regulars." The next day he said "Orderly, overtake those Oregon greyhounds . . . go mounted or you will never catch them." (OHS 017137.)

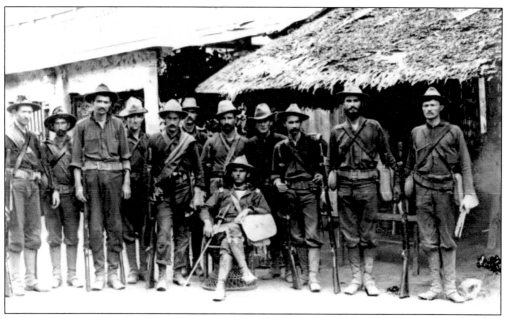

YOUNG'S SCOUTS. In late April 1899, civilian Henry Young organized a special group of volunteers to scout out areas ahead of advancing units. Young's Scouts included six members from the Second Oregon. Young died from wounds received on May 12, and Lt. James Thornton of Portland took over leadership. These scouts performed some of the most daring actions recorded, often meeting face-to-face with and routing far superior numbers. (OHS 72631.)

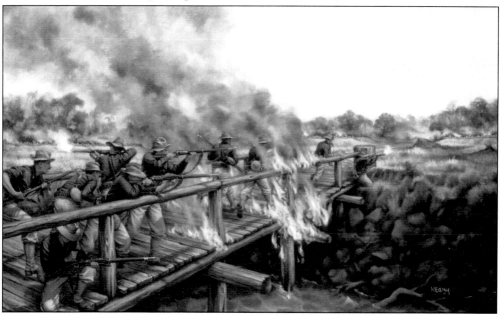

TARBON BRIDGE. On May 16, Young's Scouts encountered 600 insurgents near San Isidro. When these insurgents set fire to a critical bridge, the scouts rushed forward, put out the flames under enfilading fire, and with the Second Oregon, drove the insurgents from their trenches. Pvt. Marcus Robertson of Hood River and Pvt. Frank High of Ashland were awarded Congressional Medals of Honor for decisive action and teamwork under fire. (National Guard Heritage Series.)

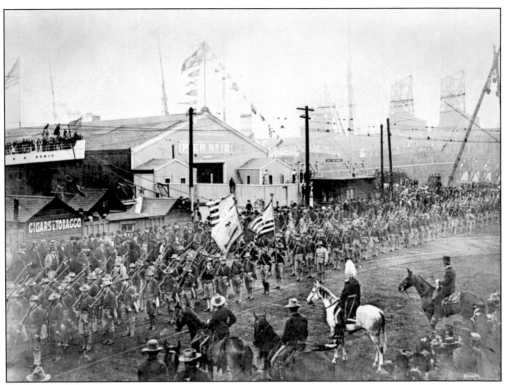

RETURN OF SECOND OREGON. Under May orders to return home, the Second Oregon fought final engagements in the Morong Expedition, then returned to Manila and on June 13, 1899, embarked on transports. They reached San Francisco on July 13 and were welcomed and honored as they marched through downtown to the Presidio. The Second Oregon mustered out on August 7 and returned to Oregon by train. (OHS OrHi 3926.)

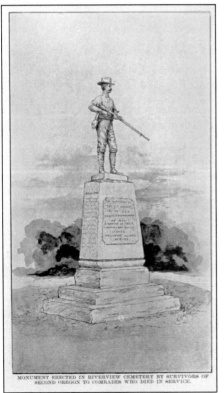

MONUMENT ERECTED IN RIVERVIEW CEMETERY BY SURVIVORS OF SECOND OREGON TO COMRADES WHO DIED IN SERVICE.

PORTLAND RIVERVIEW CEMETERY MONUMENT. Written on the monument is: "The survivors of the Second Oregon US Vol Infantry erect this monument AD 1902 in memory of their fallen comrades. Service Philippine Islands 1898–99." Volunteers in the Second Oregon suffered 65 fatalities: 13 killed in action, 4 died of wounds received in action, 43 died of disease, 1 died by drowning, 1 died by accident, and 3 went missing in action and were presumed dead.

Six

EARLY 20TH CENTURY, MEXICAN BORDER, AND WORLD WAR I
1900–1918

This period featured fluctuations in growth and organization for the Oregon National Guard and Oregon Naval Militia, organization of a Coast Artillery Corps, construction of seven state armories, several unit activations for civil support duty, activation of most of the National Guard for Mexican border duty, activation of all units for federal service during World War I, and creation of state militia units to fill the void left by activated units. After the war ended on November 11, 1918, Oregon units returned and began reorganizing in 1919 except for the naval militia, which the US Navy stopped supporting, so it disbanded.

At the start of this period, the Oregon National Guard consisted of a brigade with two regiments and a separate battalion plus a separate artillery battery and cavalry troop. It was reorganized in 1912 into one regiment of infantry, one provisional battalion of infantry, one battery of field artillery, eight companies of coast artillery, and an ambulance section. Field training encampments were held every summer. Units were called out for civil support duty in searching for escaped convicts, preventing lootings and lynchings, providing post-earthquake medical support in San Francisco, and fighting forest fires.

During this period, the US Life-Saving Service, which became the US Coast Guard in 1915, established new stations at Garibaldi (1907) and Florence (1917). Fort Stevens, an important defense installation at the mouth of the Columbia River, was the only Army post still active in Oregon.

COMPANY M, 1904. By 1900, the Oregon National Guard had reorganized as a brigade with the Third and Fourth Infantry Regiments in western Oregon, a separate infantry battalion in eastern Oregon, a battery of artillery, and two troops of cavalry. Field training camps were held each summer at locations in Oregon and Washington. Salem's Company M, Third Infantry Regiment, attended the 1904 brigade joint maneuvers camp at American Lake, Washington. (OMM.)

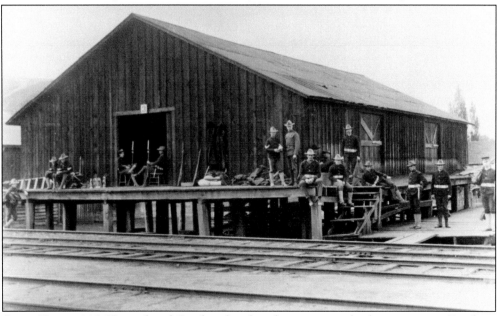

GREEK RIOT, 1905. Unemployed Greek railroad workers were involved in a riot near Roseburg that resulted in a woman's death. Several Greeks were arrested, and the sheriff feared a situation that civil authorities could not cope with. Company D, Roseburg's National Guard unit, was called out, the arrested were confined in a warehouse, and the company guarded the prisoners both from escape and from mob violence.

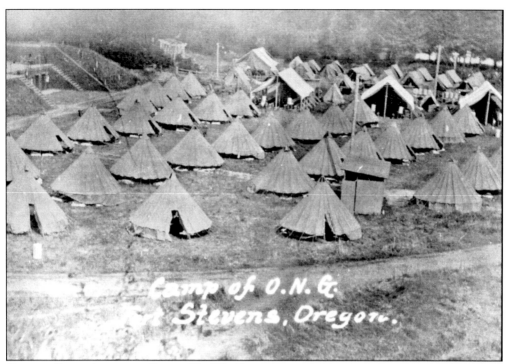

OREGON COAST ARTILLERY CORPS. The War Department urged coastal states to organize reserves to the regular coast artillery, so Oregon started organizing a Coast Artillery Corps in 1908. The First Company was organized in Astoria and participated with regular coast artillery troops in a 1909 joint encampment at Fort Stevens. By 1912, the corps had organized eight companies in Ashland, Eugene, Roseburg, Albany, Cottage Grove, Medford, and Portland.

CLACKAMAS RIFLE RANGE. In 1893, part of the National Guard held a 10-day encampment and constructed a rifle range at temporary Camp Compson by the Clackamas River near Gladstone. In 1909, the state leased 100 nearby acres for a rifle range and campground. Adjacent rail lines provided easy access from downtown Portland. In July 1909, Camp Benson was the first encampment and rifle competition held here. (OMM.)

MESS HALL AND BARN. By 1915, the Clackamas Rifle Range had grown to 256 purchased or leased acres. A mess hall, barn, quartermaster storehouse, water system, and toilets had been constructed. The barn was home for horses of Light Artillery Battery A, and it still exists, complete with individual horses' names inscribed above the stalls. (ONG.)

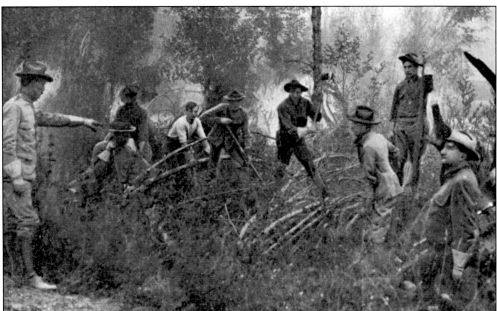

FOREST FIRE DUTY. A particularly bad forest fire season in 1910 prompted requests for the Oregon National Guard's assistance in firefighting. These fires threatened private property near Portland and Brownsville as well as Portland's city watershed near Mount Hood. The National Guard's combination of organization and discipline was cited as an important factor for successfully controlling several fires over a wide area. (ONG.)

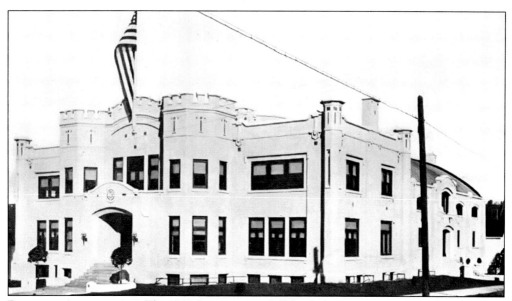

ROSEBURG ARMORY, 1914. The 1909 State Armory Bill funded construction of Oregon's first state-owned armories. By 1915, state armories had been completed at Albany, Dallas, Salem, Woodburn, Ashland, Roseburg, and Eugene. The four earlier armories were castellated, with fortified features such as corner towers and castle-like parapets. The later armories such as Roseburg's were Tudor Revival–style with a less fortified appearance. (ONG.)

 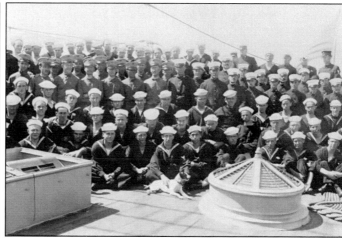

OREGON NAVAL MILITIA. The Oregon Naval Battalion was disbanded in 1905 and re-established in 1911 with units in Portland, Astoria, and Marshfield (now Coos Bay). This Oregon Naval Militia participated in regular summer training cruises on US Navy ships. In 1915, it was assigned the cruiser USS *Boston* for training and drill. By 1916, the Oregon Naval Militia even had a 38-member Marine Section. (Both, OMM.)

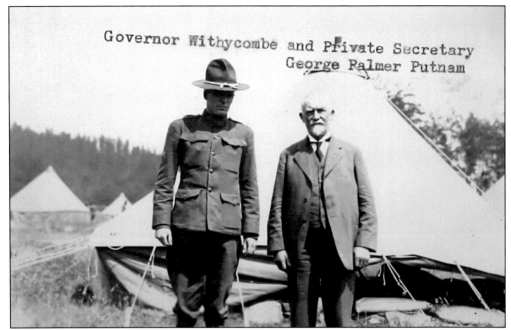

CAMP WITHYCOMBE. In 1916, Pancho Villa's Mexican rebels made cross-border raids into New Mexico and Texas. On June 18, President Wilson issued a proclamation mobilizing National Guard units from 44 states for border duty. Oregon immediately assembled the Third Infantry Regiment and separate cavalry and artillery units. Clackamas Rifle Range was their mobilization site, named Camp Withycombe in honor of Oregon's governor. In 1934, this became the site's permanent name. (OMM.)

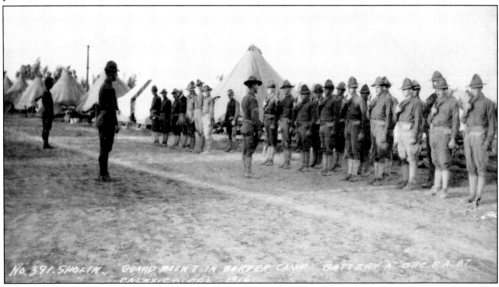

BATTERY A AT CALEXICO. On June 27, 1916, units began departing from Oregon by rail, and by July 2, all had reached their campgrounds near the California-Mexico border. Most of the units encamped initially at Balboa Park in San Diego, then moved south to Palm City and Imperial Beach. The Third Battalion encamped at San Isidro on the border near the coast, and Artillery Battery A encamped about 80 miles east at Calexico. (OMM.)

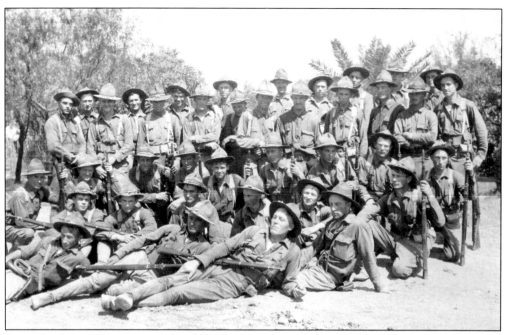

FIELD TRAINING. Troops engaged in drills, field training exercises and maneuvers, special schools, and some patrolling and security operations near the border. The Chief of the Militia Bureau 1917 annual report said many were disappointed that there was no fighting. "That they had rendered a really more valuable service to their country by preventing war rather than by making it, was realized by perhaps a few thoughtful ones only." (OMM.)

PREPARING TO GO HOME. On August 31, 1916, the Third Regiment received orders to return to its mobilization camp at Clackamas. Regimental units loaded up and returned by September 7. They went into camp, resuming drill and instruction training until mustering out on September 25. The separate Battery A, Oregon Field Artillery, and Troop A, Oregon Cavalry, were mustered out at Vancouver Barracks on February 22, 1917. (OMM.)

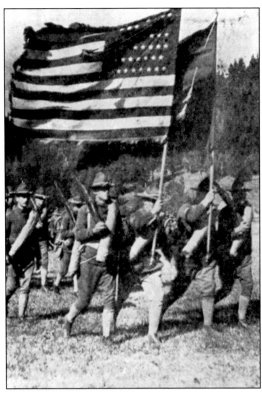

OREGON'S THIRD REGIMENT. In 1917, it appeared the United States was going to be involved in the ongoing war in Europe. President Wilson called most of the National Guard into federal service on March 15. Oregon's Third Infantry Regiment mobilized overnight and became the first regiment in the country to be ready for service. On April 6, Congress declared war on Germany. Oregon's units initially helped protect utilities from feared sabotage. (ONG.)

TRUCK ARTILLERY IN FRANCE. After war was declared, the Oregon Coast Artillery Corps, Naval Militia, and separate artillery, cavalry, engineer, and hospital units were also mobilized. The Coast Artillery Corps and Naval Militia were absorbed into other units. Most of the original Coast Artillery members served in France with heavy artillery units and saw considerable action. Oregon's Field Hospital Company became part of the 42nd "Rainbow" Division, which served in the combat zone. (OMM.)

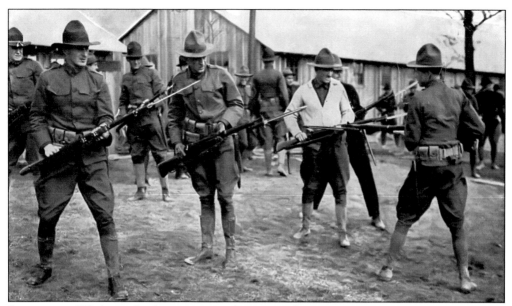

LIFE IN THE US ARMY. In the summer and autumn of 1917, Oregon's Third Regiment trained at Camp Greene, North Carolina, preparing for overseas duty. In September, Oregon's regiment became the 162nd Infantry Regiment of the 41st "Sunset" Division. National Guard units from elsewhere in the Pacific Northwest formed the other regiments of this division. The division departed for Europe in December 1917 and January 1918. (OMM.)

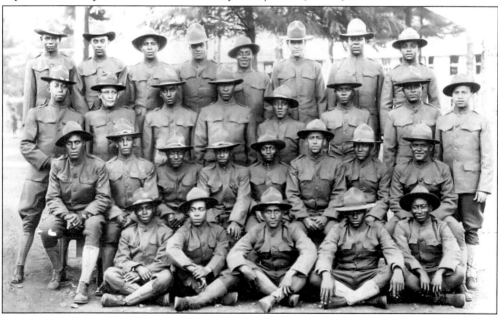

PORTLAND BUNCH. Recruited in Portland, this all-black unit formed Company 21, 166th Depot Brigade at Camp Lewis, Washington. Depot brigades received recruits, provided them with uniforms, equipment, and initial military training, and then sent them to France. The US Army's all-black units served in both support and combat. The African American 92nd and 93rd Divisions fought on the front lines. The 93rd Division served under French command and received numerous commendations. (OHS OrHi 38812.)

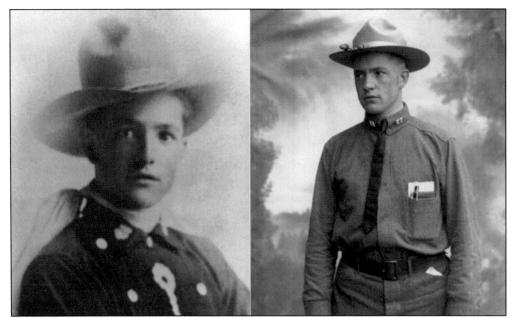

LEE CALDWELL. A well-known rodeo bronc rider from northeast Oregon, Lee Caldwell responded to the call for Oregon troops by enlisting in Pendleton's Troop D, 1st Separate Cavalry. He was elected commander and on August 17, 1917, Troop D mustered into federal service with 107 members. The unit was reorganized as a field artillery battery. Captain Caldwell served in France with Headquarters Troop, 42nd Division. (Lee Moorhouse no. 1551, UofO.)

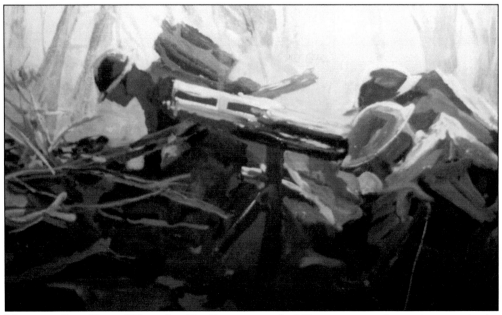

MACHINE GUN CREW. When the 41st Division reached Europe, most of its units organized a training and replacement depot in St. Aignan-Noyers, France. One Oregon battalion served in England as military police. Though the 41st Division did not serve as a combat unit, some of its units did, and many of its members and officers were sent to the front as replacements, serving in every combat sector. (John Swindley painting, OMD.)

OREGON GUARD, ROSEBURG. In 1917, local militias were organized to fill the security void left by mobilized Oregon National Guard units. In 1918, these county defense forces were formed into 35 companies of the state-created Oregon Guard. Members were unpaid volunteers provided with uniforms and arms. Note that these Roseburg members were armed with non-military lever-action rifles. (Douglas County Museum N14256.)

OREGON MILITARY POLICE. The Oregon Military Police was organized to guard Oregon's shipyards and grain districts from sabotage, to prevent civil disturbances, and to help enforce Prohibition. The former Oregon National Guard units returned in early 1919. The Military Police mustered out in February, and the Oregon Guard in April and May. The Oregon Military Police is considered by some to be the predecessor of the Oregon State Police. (Karen Roberts.)

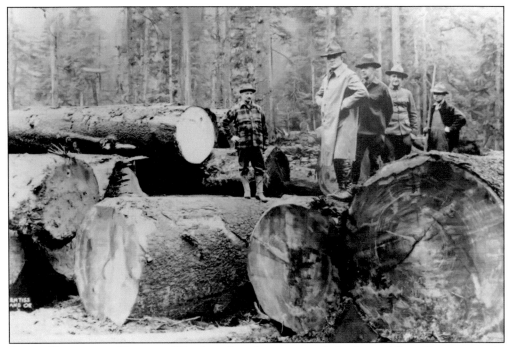

SPRUCE PRODUCTION DIVISION. Wood products became greatly in demand for military use, so in November 1917, the US Army organized the Spruce Production Division to harvest Sitka spruce, which was used primarily for constructing military airplanes. Headquartered in Portland, this division employed about 19,000 soldiers and 10,000 loggers and millworkers. They built roads and mills and harvested considerable spruce from the Pacific Northwest's Coast Range. (Marion County Historical Society Museum.)

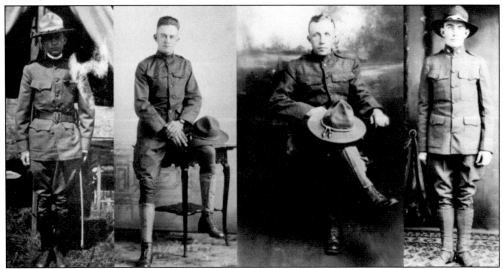

FOUR OREGON SOLDIERS. This unidentified lieutenant and three privates are representative of the Oregonians who served during World War I. Oregon furnished 44,166 citizens for armed forces duty. Of these, 367 were killed in action, 663 died of other causes, and about 1,100 were wounded in action. Oregonians were awarded 355 citations and decorations, including one Congressional Medal of Honor, 35 Distinguished Service Crosses, and 96 French Croix de Guerre.

Seven

INTERWAR PERIOD AND WORLD WAR II
1919–1945

Following World War I, the Oregon National Guard organized the 162nd and 186th Infantry Regiments as part of the Pacific Northwest's 41st Division, along with the separate 249th Coast Artillery Battalion. By 1938, the Oregon National Guard's aggregate strength was 3,603 officers and men, the largest in the state's history.

Oregon had a unique role in World War II. Its location on the West Coast made it both a target and the first line of defense for possible Japanese invasion. Also, the 41st Division, because of its reputation as a well-trained division led by Maj. Gen. George White, was called to active duty over a year before the attack on Pearl Harbor. It trained at Camp Murray, Washington, and Camp Roberts, California. After the December 7, 1941, attack on Pearl Harbor, the 41st Division's first wartime mission became coastline defense in Oregon and Washington.

Reorganized as the 41st Infantry Division, it was relieved of coastline defense and deployed to Australia to begin 45 months of service in the Southwest Pacific theater. It trained in Australia, fought through New Guinea and the Philippines, and went on to occupy the Kure-Hiroshima district of Japan. Oregon's Sunset Highway and Beaverton's Sunset High School are named to honor the 41st "Sunset" Infantry Division.

Oregon also had multiple military sites, mostly new: Pendleton Army Airfield, which initially housed part of the future Doolittle Raiders and then the 555th Parachute Infantry Battalion; Umatilla Army Depot; Tillamook Naval Air Station, housing blimps; Fort Stevens, a historic site defending the Columbia River mouth; Camp Adair, a site for training four infantry divisions, then becoming a prisoner of war camp and tropical disease hospital; Camp White, a site known especially for training Army nurses; Camp Abbott, site of the famous Oregon Maneuvers and an engineer replacement training center; Swan Island, the initial site of the Oregon National Guard's 123rd Observation Squadron; and many others.

Oregon experienced four enemy attacks: a submarine fired rounds towards Fort Stevens, a submarine-launched airplane conducted two bombing missions on southern Oregon forests, and a Japanese balloon bomb exploded outside of Bly, killing six citizens, the only casualties in the mainland United States during World War II. Balloon bombs also ignited a few minor forest fires.

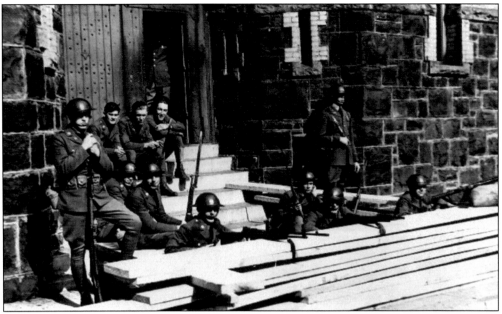

CIVIL SUPPORT DUTY. In 1934, almost 2,000 Oregon National Guard troops were called out for 12 days during a strike by longshoremen and maritime workers. Some troops were stationed at the armory in Portland, but most stood by at Camp Withycombe until the strike was over. During this interwar period, troops also responded to four forest and town fires, including the famous Bandon fire of 1936. (OHS CN 005984.)

COAST ARTILLERY OBSERVING STATION. The 249th Coast Artillery, Oregon National Guard, was considered an elite unit due to accomplishing some of the Army's most complex missions, demanding a high degree of proficiency from all members. The 249th was awarded the coveted Coast Artillery Association Trophy for Proficiency in 1938, the first time a National Guard unit had ever received this award. This picture is of Battery C, 1st Battalion. (ONG.)

GEORGE A. WHITE. White was Oregon's adjutant general before and after World War I, serving on Gen. John Pershing's staff during the war as a lieutenant colonel, then a colonel. White was instrumental in the creation of the American Legion. In September 1929, Major General White was given command of the 41st Division, which was called to active duty on September 16, 1940. Under his leadership, the 41st quickly gained the reputation as the most capable National Guard division. (ONG.)

186TH REGIMENT ISSUED THE M1. Eugene Winters from E Company relaxes after a road march on Fort Lewis with his new M1 Garand. Because of its development of well-trained marksmen, the 186th Regiment was selected in 1939 to receive the initial National Guard issue of the M1 Garand. This was the US Army's first standard issue semi-automatic military rifle. (Fred Hill.)

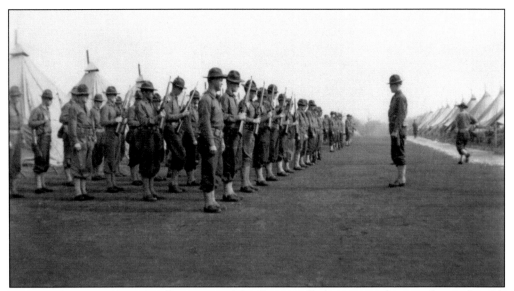

BAKER'S COMPANY F, 186TH REGIMENT. After being called to active duty on September 16, 1940, Company F and other units of the 41st Division occupied Camp Murray, adjacent to Fort Lewis, Washington. They spent a wet winter in this tent city and nicknamed it "Swamp Murray." In February 1941, they began moving into newly constructed barracks at North Fort Lewis. (Carl Davis.)

HUNTER LIGGETT TRAINING. In the summer of 1941, the activated 41st Division traveled to Hunter Liggett Military Reservation in California for additional training with other Army and National Guard divisions and won those mock battles. Here, Sgt. George Blake walks up E Company's street showing the field tents that the soldiers set up. Each soldier was issued half a tent, requiring a buddy to have the other half. (Fred Hill.)

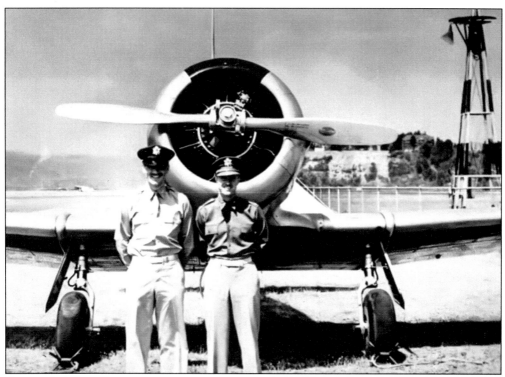

OREGON'S 123RD OBSERVATION SQUADRON. Created in April 1941 at Swan Island Airport in Portland, this squadron was soon activated and trained at Fort Lewis. On the day of the Pearl Harbor attack, the 123rd launched the first combat air mission from the United States to look for submarines or other enemy activity on the Oregon-Washington coastline. Reorganized as the 35th Photo Reconnaissance Squadron, it was sent to China in April 1944. (ORANG.)

FATHER OF OREGON'S AIR GUARD. Maj. G. Robert Dodson commanded the 123rd Observation Squadron from its organization through its activation into federal service until it was reorganized, with many of its members going to other air units. Upon his return from World War II, Dodson organized the postwar Oregon Air National Guard program. He was promoted to brigadier general and named chief of staff before his death in 1958. (ORANG.)

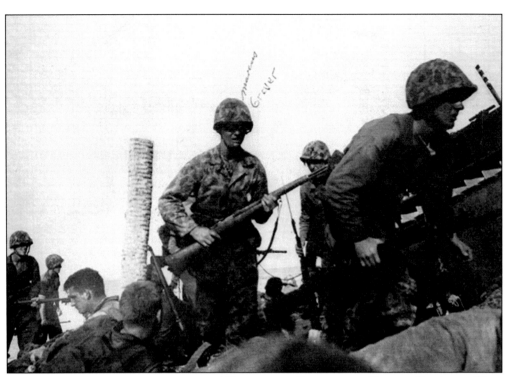

OREGONIANS SERVE IN THE PACIFIC. By virtue of its location on the western side of the United States, Oregon sent a majority of its young men and women to the Pacific theater. Even before the war started, Oregonians were working for military contractors preparing for war in places like Wake Island, which the Japanese attacked on December 7, 1941.

ROSEBURG BROTHERS DIE. On June 18, 1944, 3rd Battalion, 8th Marines engaged the Japanese on Saipan, and Cpl. Grover Wells (previous image) was cut down. His brother Earl Wells (pictured) joined the unit three months later, and on Okinawa on June 18, 1945, Private Wells was also cut down. The two brothers were killed on the same day one year apart. They were author Alisha Hamel's great-uncle and grandfather; her grandmother was pregnant with the author's mother. (Earl Bradshaw collection.)

41ST INFANTRY DIVISION HEADS OVERSEAS. In February 1942, the 162nd Regiment traveled by rail to New York, then sailed through the Panama Canal to reach Australia. The rest of the division sailed from San Francisco, all ultimately arriving in Melbourne, the first American division to arrive in Australia. Sgt. Gim Chin, of Chinese descent, was desperate to fight the Japanese but was assigned to Gen. Douglas MacArthur's security detail. (Gim Chin.)

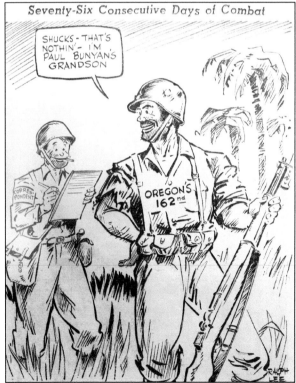

76 CONSECUTIVE DAYS OF COMBAT. In February 1943, the 162nd Regiment's first mission was to advance in support of the Australians attacking Salamaua, with the objective of capturing the Mubu Airstrip. At Nassau Bay, this advance utilized one of the first amphibious landings of World War II, taking over three days to route the Japanese defenders on the beach. The 162nd continued into the mountainous region to take the airstrip. (41st Division Association.)

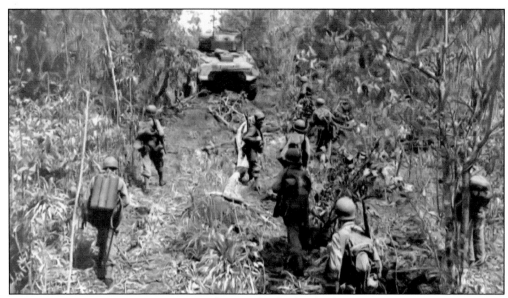

41st Fights through New Guinea. The 41st fought for the first time as an entire unit on the island of Biak in mid-1944. With bad intelligence regarding the number of Japanese defenders, the battle took three months. The men of the 41st called it "Bloody Biak." In May 1944, the first tank battle of the Pacific was fought there, with Sherman medium tanks overwhelming the Japanese Ha-Go light tanks. (OMM.)

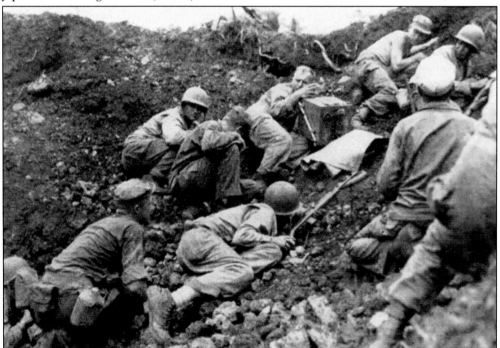

41st in the Philippines. In February and March 1945, units of the 41st Infantry Division began participating in three Eighth Army campaigns on the southern Philippines islands of Palawan, Zamboanga, Sulu, and Mindanao. On August 11, the mission of the Eighth Army was declared at an end and preparations began for the invasion of Japan. (41st Infantry Division Association.)

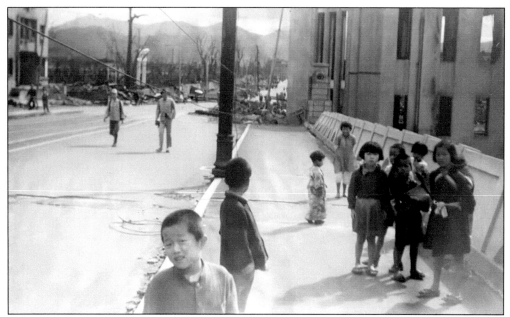

HIROSHIMA. After the Philippines were secured, the 41st Infantry Division was scheduled to be one of the lead units to invade the Japanese island of Kyushu. After the dropping of the atomic bombs and Japan's August 15, 1945, surrender, the 41st occupied Japan in the area of Kure in the Hiroshima Prefecture. Many division members traveled to Hiroshima to take pictures such as this. (Carl Hellis collection, OMM.)

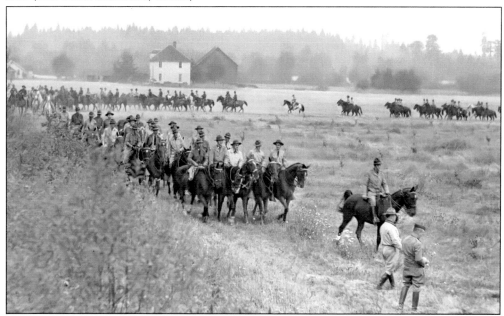

OREGON STATE GUARD. Following the attack on Pearl Harbor, Oregon's governor, Charles Sprague, ordered the immediate organization of a state guard to fill the void left by the activated National Guard. By October 1942, the Oregon State Guard had 8,591 members organized into 23 battalion sectors, a regiment, and 9 troops of cavalry. Its mission was protection from invasion and sabotage as well as response to domestic emergencies. (OMM.)

JAPANESE SHELL CRATER. The 249th Coast Artillery manned Fort Stevens during World War II, protecting the mouth of the Columbia River. On the night of June 21, 1942, a Japanese submarine fired rounds towards Fort Stevens (the only base attacked in the continental United States during the war). The men ran to their battle stations but were ordered to not fire back. There were no casualties. (OHS Dig no. bb013822.)

COMMANDER TAGAMI AND CAPTAIN WOOD. Submarine *I-25* commander Meiji Tagami determined there could be no mines where he saw fishing boats along the Oregon coastline and ordered the firing of 17 rounds toward Fort Stevens. Capt. Jack R. Wood, Fort Stevens Battery Russell commander, determined the submarine was out of range and fishing for evidence of a military post, and never received the order to fire back. His battery was ready! (Army Signal Corps.)

CAMP ADAIR CREATED. Located north of Corvallis in Polk and Benton Counties, Camp Adair was created to train Army troops during World War II. The site was selected because of its topography and access to rails, water, and electricity. Four divisions trained at Camp Adair: the 104th "Timberwolf" Division, the 70th "Trailblazer" Division, and the 96th and 91st Infantry Divisions. Three of these divisions were created at Camp Adair. (Polk County Museum.)

SWAMP ADAIR. The soldiers training at Camp Adair quickly dubbed it "Swamp Adair" because of the near constant rain during winter training and the mud resulting from land clearing to make the camp. Camp Adair housed over 100,000 troops, then became a camp for German and Italian prisoners of war, and next a major medical recovery center commissioned by the Navy for returning Pacific theater veterans. (ONG.)

HOME OF THE 555TH. Pendleton Army Airfield was built in 1941 in anticipation of the possibility of the United States going to war. It housed part of the 17th Bombardment Group, later famous for the Doolittle Raid. In 1945, the 555th "Triple Nickel" Parachute Infantry Battalion was based there to fight forest fires started by Japanese balloon bombs. These 555th smokejumpers are ready. (Airborne and Special Operations Museum.)

OPERATION FIRE FLY. The 555th was created at Fort Benning and was the only African American parachute unit. It was destined to fight in the European theater, but because of the nearing end of the war in Europe, it was redirected to Pendleton Army Air Field to fight forest fires. Unfortunately, the soldiers still faced racism in Pendleton. Reportedly only one restaurant and two bars would serve them. (Airborne and Special Operations Museum.)

JAPANESE BALLOON BOMBS. Prior to World War II, high altitude jet streams were discovered. Japan decided to take advantage of this and created balloon bombs designed to rise to the level of the jet stream and float towards North America in the hopes of starting forest fires. It was felt that if forest fires became a big enough challenge, the United States would have to pull troops from the Pacific.

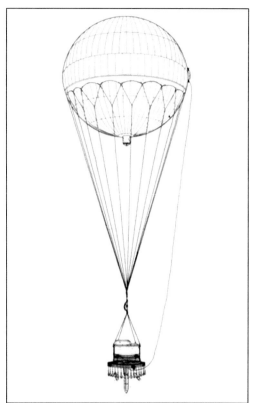

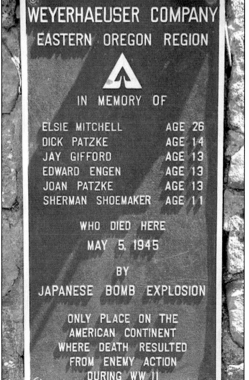

THE ONLY US MAINLAND CASUALTIES. On May 5, 1945, a Sunday school teacher, her preacher husband, and five Sunday school students went into the mountains near Bly to have a picnic. The preacher dropped off his wife and students and went to park the car. As he got out of the car, he heard his wife say "Honey, look what we found." The balloon bomb exploded, killing six. This Mitchell Monument honors those six casualties.

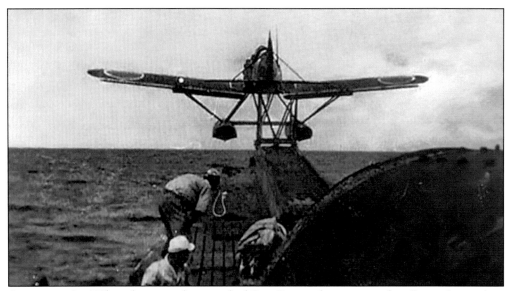

ATTACK BY AIR! The submarine that attacked Fort Stevens later returned to Oregon's coastline and on September 9, 1942, surfaced off the south coast near Brookings. A "Glen" seaplane was launched by catapult to bomb Oregon's forests, hoping to start a forest fire. The plane dropped two bombs. One landed on Wheeler Ridge near the Mount Emily lookout and started a fire that the forest service crew quickly extinguished.

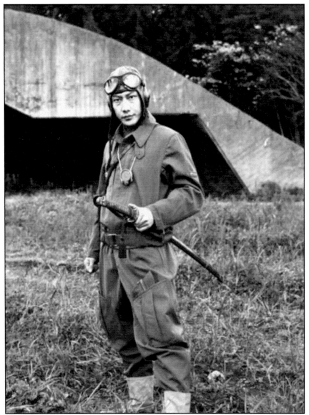

FOE, THEN FRIEND. Glen seaplane pilot Nubuo Fujita flew back to the submarine *I-25* and three weeks later, flew another unnoticed bombing mission near Cape Blanco. The submarine returned to Japan, where Fujita's next mission was training kamikaze pilots. He felt so bad about his role in World War II that he returned to Brookings in 1962 and presented the city his 400-year-old samurai sword, now displayed in the Brookings library.

CAMP ABBOT. Named for Brig. Gen. Henry Abbot, who camped at the site in 1855, Camp Abbott was constructed along the Deschutes River south of Bend. It was used to train combat engineers, and the first trainees arrived in March 1943. Over 90,000 troops trained here before it was closed in June 1944. The Great Hall at Sunriver Resort is the only remaining structure from Camp Abbot. (OHS Dig no. bb012604.)

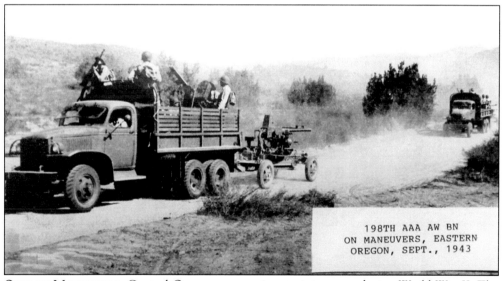

OREGON MANEUVERS. Central Oregon was a prime training area during World War II. The Oregon Maneuvers, located east of Camp Abbott, trained entire infantry divisions in movement operations. Units from Camp Adair relocated for the maneuvers and trained under Maj. Gen. Alexander Patch. The maneuver included five specific training problems, pitting the Red Force against the Blue Force. Most of the units bivouacked along US Route 20 between Sisters and Bend. (MilitaryMashUp.com.)

NAVAL AIR STATION TILLAMOOK. In March 1943, the US Marines of Lighter Than Air Squadron ZP-33 arrived at the new Naval Air Station Tillamook. The station's two hangars were still under construction. When completed, they housed eight 252-foot-long non-rigid airships used for antisubmarine patrol and convoy escort. These K-class airships could stay aloft for three days and had a range of 2,000 miles. (John W. Sherman.)

TILLAMOOK AIRSHIP HANGAR. The two US Navy airship hangars in Tillamook were cavernous structures supported by Douglas-fir wood trusses. They were 195 feet (16 stories) high, 296 feet wide, and 1,086 feet long—a record for wood construction. Seventeen such structures were built around the nation. After the war, the Tillamook hangars housed lumber milling operations and other industrial activities. One became the Tillamook Air Museum.

OREGON PILOT SHOOTS DOWN YAMAMOTO. Lt. Rex Barber from Culver, Oregon, was credited with shooting down Admiral Yamamoto, architect of the Pearl Harbor attack. As a P-38 pilot, Lieutenant Barber was tapped to fly a mission based on a radio interception telling of the Yamamoto flight in the Southwest Pacific. Barber came back from this April 18, 1943, mission with 104 bullet holes in his airplane. He was awarded the Navy Cross.

OREGON WOMAN AWARDED MEDAL OF FREEDOM. Claire Phillips from Portland operated a nightclub in Japanese-occupied Manila, portraying herself as an Italian. She smuggled food and medicine to American prisoners of war and gathered intelligence used by the Americans and Filipino guerrillas to fight the Japanese. Discovered, captured, tortured, and sentenced to death, she survived and in 1948 became the first woman awarded the nation's highest civilian decoration. (OHS 001275.)

LEONARD DEWITT. On July 27, 1943, Sergeant DeWitt was the only defender holding off Japanese trying to retake the ridge his unit was holding. The next morning, his unit found evidence of at least 20 Japanese casualties. Recommended for a Medal of Honor for saving his unit, he was awarded the Distinguished Service Cross. Dying in June 2016, he was the last living 41st Infantry Division recipient of this award. (Leonard DeWitt.)

25 DISTINGUISHED SERVICE CROSSES. Medic Frank Gehrman received a Distinguished Service Cross for saving lives from areas of heavy mortar, artillery, and machine gun fire on the island of Biak without regard for his own safety. The 41st Infantry Division received no Medals of Honor and only 25 Distinguished Service Crosses during World War II, a bad oversight. Its sister division the 32nd received 11 Medals of Honor and over 167 Distinguished Service Crosses. (Frank Gehrman.)

Eight

POSTWAR AND COLD WAR
1946–1991

After World War II, Oregon's National Guard units returned from federal service and reorganized into the Oregon Army National Guard (ORARNG) and Oregon Air National Guard (ORANG). The 41st Infantry Division became the Pacific Northwest's major Army National Guard unit, with its 162nd and 186th Infantry Regiments located in Oregon. The 249th Coast Artillery reorganized as the 249th Artillery Group (Air Defense), then in 1971 reorganized as the 1249th Engineer Battalion. In 1946, the ORANG reorganized as the 123rd Fighter Squadron and 371st Fighter Group, which ultimately reorganized into the 142nd Fighter Wing.

The Oregon State Guard was deactivated in 1948, revived for two years during the Korean War as the Oregon National Guard Reserve, then organized again in 1961. It was redesignated the Oregon State Defense Force in 1989.

Many events occurred during this time. The ORANG base at Portland Airport went underwater during the 1948 Vanport Flood. In 1951, ORANG units were called to federal service during the Korean War. No units went overseas, but nine pilots were assigned to combat units in Korea. After the 1962 Columbus Day storm, several Oregon National Guard units and members performed state duty in Portland, Salem, Albany, Cottage Grove, Newport, and Newberg. National Guard members assisted during Labor Day riots in Seaside and continued to help with floods and forest fires.

In 1961, the Oregon legislature officially created the Oregon Military Department. The 41st Infantry Division was deactivated in 1968. Its colors and honors were transferred to the 41st Infantry Brigade, an Oregon-only unit. In 1970, Oregon units received the M16 rifle, replacing the M1 and M14.

No Oregon Guard units were activated during the Vietnam War, but units were at full strength during this time. Operation Tranquility was a successful endeavor designed by Gov. Tom McCall to keep antiwar protests from disrupting the 1970 American Legion National Convention in Portland. It featured two outdoor rock festivals that diverted many would-be protestors. A large contingent of Oregon National Guard troops trained in crowd control but mostly ended up just standing by.

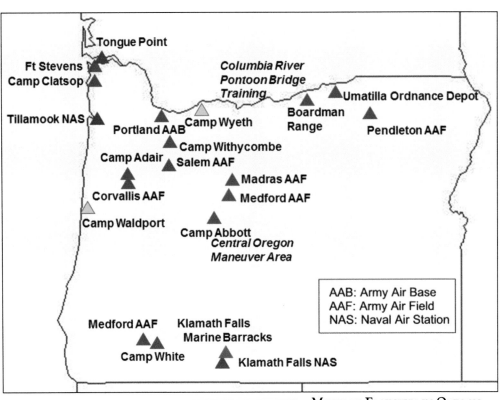

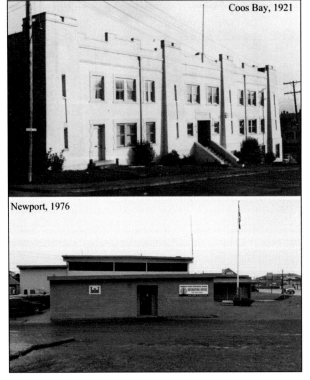

Coos Bay, 1921

Newport, 1976

MILITARY FACILITIES IN OREGON. During World War II, over 20 Army, Navy, and Marine posts and training sites were established in Oregon. Oregon National Guard Camps Clatsop and Withycombe were also in use. Almost all have been deactivated since the war, but Portland, Klamath, and Pendleton Air Bases are current Air National Guard facilities, and Camp Clatsop (now Camp Rilea) and Camp Withycombe are current Army National Guard facilities.

ARMORIES. During the 1920s and 1930s, nine armories were constructed in various styles, including Eclectic, Tudor Revival, Art Deco, and Moderne. In the decade after World War II, nine Quonset hut–style armories were constructed, then 10 Multi Vehicle Storage Building–style armories were constructed with 75 percent federal funding. Twenty-three more armories were constructed from 1954 through 1978. (OMD.)

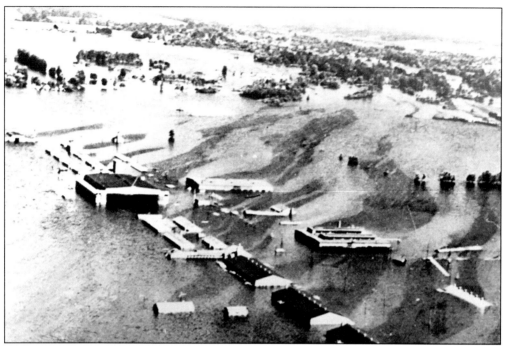

VANPORT FLOOD. On May 30, 1948, the swollen Columbia River breached a dike and flooded Vanport, a city built during World War II on Portland's northern edge. The Portland Air Base also flooded, but because it happened over a holiday weekend, there were no casualties from base flooding. Even though the base suffered extensive equipment loss, there was plenty of wine and pickles courtesy of wooden barrels floating by. (ORANG.)

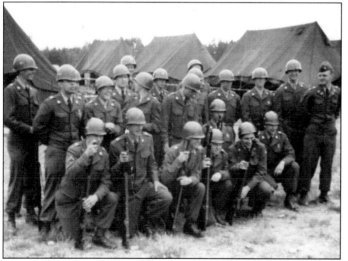

KOREA/VIETNAM-ERA PLATOON. Pendleton's Company G, 186th Infantry, attended 1953 field training at Camp Murray, Washington. Author Warren Aney joined Company G in April and trained as a first platoon Browning Automatic Rifleman. No Oregon units served in Korea or Vietnam, but they maintained a high level of training as part of America's reserve force. The 142nd Fighter Group was activated during the Korean War, but no units left the country.

Ernie Wakehouse. First Lieutenant Wakehouse was one of the nine 142nd Fighter Group pilots assigned to combat units in Korea. Each had to fly 100 missions (in an F-51 Mustang) before they could head home. Many flew two or three or more missions a day in hopes of getting home earlier. One of the pilots, 1st Lt. Orval Tandy, was shot down and became a prisoner of war for two years. (ORANG.)

Mineo Inuzuka. Sent from Portland to a Japanese internment camp during World War II, Inuzuka was drafted out of camp and served with the 442nd Regimental Combat Team. After the war, he was sent to an assignment in Japan as an interpreter, though he spoke very little Japanese. In 1951, First Lieutenant Inuzuka received the Distinguished Service Cross for extraordinary heroism in action near Chango-Ri, Korea. (Mineo Inuzuka.)

DESEGREGATION. On July 26, 1948, President Truman signed Executive Order 9981, ending all segregation in US military forces. World War II veteran, college graduate, and school teacher Earl Winchester (right) broke the Oregon National Guard's unofficial segregation barrier after he requested enlistment in 1955. He quickly advanced to first sergeant, remaining in the Oregon National Guard until 1974. Here he meets with Maj. Gen. Stanley Larsen (left) and Brig. Gen. David Baum. (OMD.)

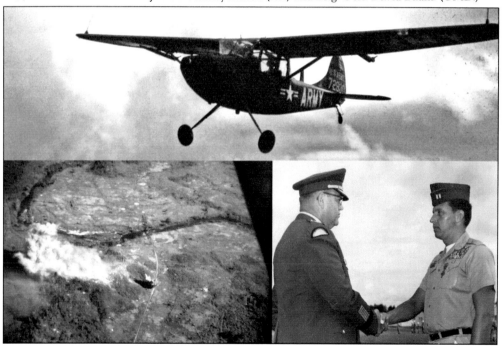

CHARLES "LARRY" DEIBERT, COMBAT HERO. Flying an O-1 Bird Dog observation aircraft on September 10, 1967, Captain Deibert was called on to support a Marine battalion engaged with a much larger North Vietnamese Army force. He made risky low-level flights, marking enemy targets for strike planes. One of his marking rounds was so accurate that it disabled three machine gun positions. For this action, he was awarded the Distinguished Service Cross. (Charles Deibert.)

MACIL FLYE, NON-COMBAT HERO. On July 28, 1972, Maj. Macil L. Flye was in a CH-54 helicopter that crashed in Alaska, killing the aircraft commander. Drenched in fuel and with an injured back, Major Flye helped fellow guardsmen and crewmembers climb out. When it appeared the helicopter was going to burn, he climbed back in and removed the pilot's body. He was awarded the Soldier's Medal. (OMD.)

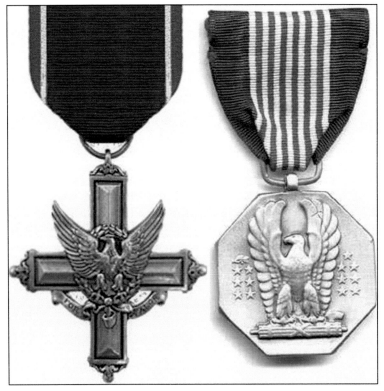

HERO'S MEDALS. Created in 1918, the Distinguished Service Cross is the US Army's second-highest award for combat heroism. The Soldier's Medal is the highest honor that a soldier can receive for non-combat heroism. Cpl. Loren Clevenger of McMinnville, a member of Company A, 162nd Regiment, was the first Oregonian to receive the Soldier's Medal, doing so in June 1935 for rescuing a fellow soldier from the riptide at Seaside.

HELPING THEIR COMMUNITY. The Innovative Readiness Program officially started in 1984 and operated with three main functions: medical, engineering, and transportation. Oregon Guard members helped their communities and kept their skills sharp by training for wartime missions and then using these skills to enhance their communities. In the 1960s, Oregon engineer unit members built this bridge over a creek, connecting a trail. (OMD.)

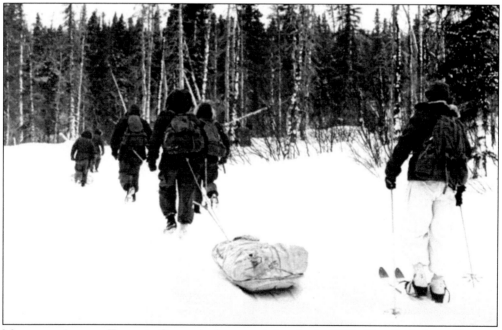

MISSION IN ALASKA. Troops in Oregon had many missions in the 1960s. The 41st Infantry Division was given an additional national defense mission of protecting Alaska, so it trained in northern operations. Many annual field training sessions were held in Alaska. Here Oregon troops pull their supplies after them as they maneuver into the tree line. (OMD.)

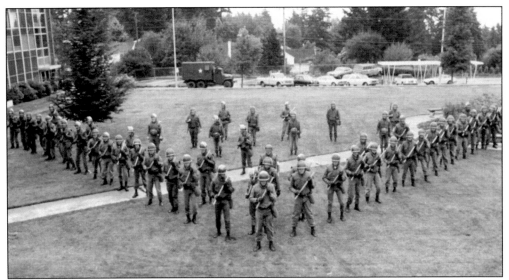

OPERATION TRANQUILITY. In August 1970, the 41st Infantry Brigade went to Fort Lewis for two weeks of annual training. Antiwar protests were a looming threat in Portland, so the regular training schedule was scrapped and troops switched to learning crowd control techniques from experts, primarily the Oregon State Police. This training resulted in units prepared for nonlethal crowd control, which meant batons and protective masks instead of rifles and bayonets. (OMD.)

GUARDING A PORTLAND RESERVOIR. In late August, 4,700 Oregon Army National Guard troops were put on state active duty for the duration of the American Legion National Convention in Portland. Another 1,300 were on alert. Four hundred troops guarded critical facilities such as water reservoirs; one of the typical rumors circulating was that attempts would be made to spike the city's water supply with hallucinogens. (OMD.)

VORTEX I. Oregon's governor, Tom McCall, sponsored an outdoor rock festival at McIver State Park, well away from downtown Portland. A privately sponsored rock festival was also held in nearby Woodland, Washington. These festivals drew at least 27,000, including many potential protestors. Part of a National Guard armored cavalry battalion provided external security during the rock festival, primarily to protect private property in the area. (OMD.)

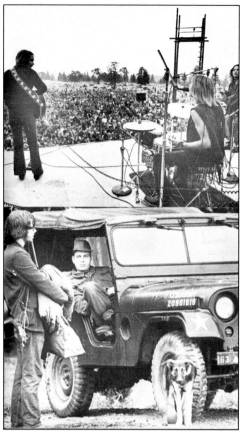

NATIONAL GUARD PRESENCE. Each day during the American Legion convention, a brigade of Oregon Army National Guard troops was positioned in parking garages and basements in downtown Portland. These troops arrived early in the day and left late in the afternoon. Though they were not visible as a force, this pre-positioning was well publicized. National Guard concentrations were out of sight but not out of mind. Operation Tranquility became a recognized success. (OMD.)

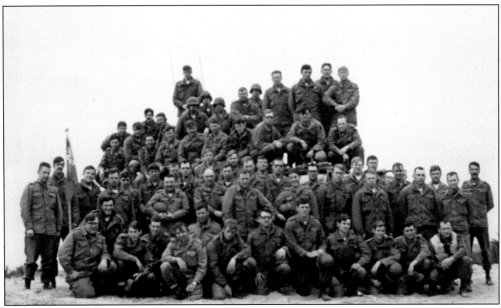

249TH COAST ARTILLERY. The famous 249th Coast Artillery, a very proud unit in the Oregon National Guard, was reorganized into the 1249th Engineers in the 1970s. Here is a picture of B Battery's last annual training session after the last round was fired by the battalion commander. (1st Lt. Dennis Abraham.)

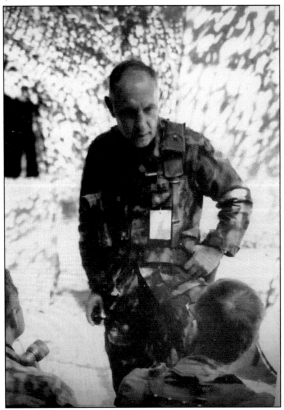

BRIG. GEN. DAVID NUDO. A 9th Division World War II veteran and 41st Infantry Brigade commander, Brigadier General Nudo's proudest moment was when the 41st Brigade participated in a 1981 operation called CRISEX81 in Spain. This operation highlighted how well-trained his troops were and how they could participate successfully on the international scale. He also was instrumental in the Peabody Award–winning documentary *Ready on the Firing Line*. (David Nudo.)

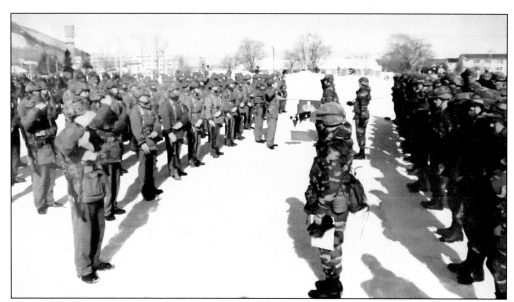

YAMA SAKURA. Oregon troops have participated in Yama Sakura many times since this annual bilateral exercise started in Japan in 1982. Yama Sakura rotates to each Japanese army region for a five-year rotation. This picture is of the rotation in Camp Higashi-Chitose in Hokkaido, Japan, a sister city to Portland, Oregon. Troops learned quickly of the importance of shoe chains, which prevented many slippages due to icy conditions. (OMM.)

FOREST FIRES. In 1987 and 1988, the Oregon National Guard was called on to help fight forest fires. Several hundred Oregon Guard members volunteered and were put on state active duty orders to serve in southern and northeastern Oregon. Here, soldiers fight the 1988 Troy and Teepee Butte Forest Fires in Wallowa County. The soldiers primarily did the dirty cleanup work after the trained firefighters had tamed the main fire.

206TH ATMCD ACTIVATED. On August 27, 1990, the 206th Air Terminal Movement Control Detachment became the first Oregon Army National Guard unit called into federal duty since World War II. In Operation Desert Storm, the unit managed movement of all troops coming by air, so it was among the first to arrive and among the last to leave. Here, detachment troops are in an air raid shelter because of Scud missile threats. (Stacey Nelson-Hale photograph.)

FEMALES CALLED TO ACTIVE DUTY. The 206th had the first Oregon females to be called up for federal duty with their unit. The 206th was about 40 percent female, creating Oregon history. Females in the unit were in command positions and line positions. Here, author Alisha Hamel stands in the unit's first station, Camp Jack in Saudi Arabia. She served as the 93rd Transportation Battalion S-1 personnel officer during Desert Storm.

Nine

POST–COLD WAR AND WAR ON TERROR

1992 TO PRESENT

This chapter portrays only part of the many unit deployments experienced by Oregon National Guard units during this period.

As the world transitioned into the post–Cold War period and the War on Terror, Oregon started to routinely send troops federalized to support the United States in many different operations. The first Home Station deployment happened when the 41st Personnel Services Company was called to active duty in support of Operation Joint Endeavor in Bosnia in January 1996. By allowing specialized training and transition within its own state, 41st Personnel Services Company served as a role model to other states. The 82nd Rear Tactical Operations Center also deployed to Bosnia in 1997.

In 1998, Oregon National Guard units participated in a large training exercise at the Joint Readiness Training Center in Fort Polk, Louisiana, providing them with an advanced level of joint training. The Oregon Air Guard's 142nd Fighter Wing supported Operation Northern Watch at Incirlik Air Base in Turkey in 1998, and the 270th Air Traffic Control Squadron was sent to Hungary for Operation Joint Guard.

In 1999, the 1042nd Medical Company Ambulance deployed to Turkey, while the 1st Battalion, 186th Infantry, deployed to Japan for Operation North Wind. Also, C Company, 1st Battalion, 162nd Infantry, and B Company, 1st Battalion, 186th Infantry, were sent to Saudi Arabia, and C Company, 2nd Battalion, 162nd Infantry, was deployed to Kuwait. These latter two companies were responsible for providing force protection to Patriot missile batteries. The 115th Public Affairs Detachment was sent to Bosnia, and the 4-1241 Testing, Maintenance, and Diagnostic Equipment Company was sent to Bosnia and Kuwait.

1042ND AIR AMBULANCE COMPANY. In April 2002, this unit deployed to Afghanistan, Kuwait, and Saudi Arabia with 112 soldiers and a dozen helicopters. Their mission was medical evacuation and initial treatment. They returned from deployment to the accolades of a grateful nation, receiving the Best Aviation Unit in the National Guard Award and the Small Unit Deployment Excellence Award. (OMD.)

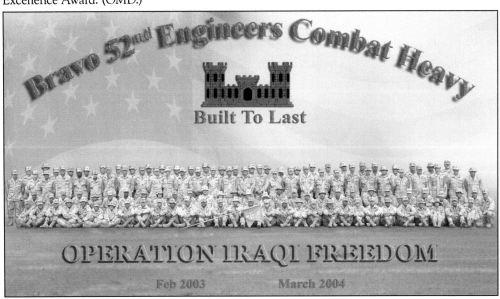

B COMPANY, 52ND ENGINEERS. Deployed in 2003, Bravo Company had the dubious distinction of being the first Oregon unit since World War II to have a soldier killed in action, Spec. Nathan Nakis. Another mission resulted in the first Purple Hearts awarded since World War II to members of an Oregon unit. Bravo Company operated in dangerous situations accomplishing important construction projects, including an orphanage, and training Iraqis in construction. (OMD.)

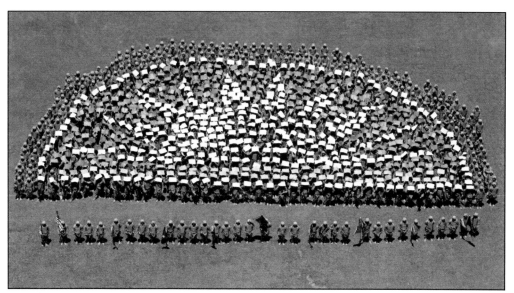

41st Combat Patch. The 41st Infantry Brigade's 2003 deployment became the first mobilization since World War II where the 41st "Sunset" Infantry Division (Brigade) patch was authorized to be worn as a combat patch by activated members. This also marked the first time that the Combat Infantryman's Badge was earned by those soldiers meeting its criteria during the deployment of the Brigade's 1st Battalion, 162nd Infantry, to Iraq. (OMD.)

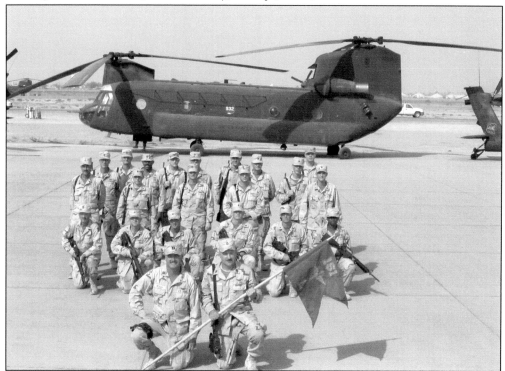

L Company's 2nd Platoon detachment. In 2004, members of 2nd Platoon, L Company, 151st Aviation Intermediate Maintenance Battalion deployed to Balud, Iraq, with the mission of maintaining 120 helicopters. They returned to Oregon in February 2005. (OMD.)

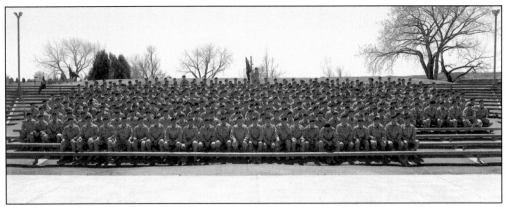

2-162 INFANTRY HAS HIGHEST CASUALTIES. In April 2004, the 2nd Battalion, 162nd Infantry, deployed to Operation Iraqi Freedom, sending 700 soldiers to Baghdad, Fallujah, Mosul, and Najaf. They encountered fierce fighting and sustained eight soldiers killed in action: 1st Lt. Eric McCrae, Sgt. Justin Eyerly, Spec. Justin Linden, Spec. Eric McKinley, Spec. Ken Leisten, Sgt. Ben Isenberg, Sgt. David Weisenberg, and Sgt. David Johnson. (OMD.)

RESTING AFTER A FIREFIGHT. PFC Andrew Stocker (left) and Sgt. Ryan Searls served as an artillery forward observer team in Company A, 2nd Battalion, 162nd Infantry. In early August 2004, their company fought elements of the Mahdi Army at the Jamelia Power Station near Baghdad. This was the battalion's first major engagement. (OMD.)

SILVER STAR RECIPIENT. In 2005, Sgt. Matthew Zedwick from Bend, Oregon, became the first Oregon Guard member since World War II to receive the Silver Star, the US Army's third-highest valor award. Sergeant Zedwick received this honor for his heroism in providing aid to his fellow wounded soldiers and providing security under heavy enemy fire. Oregon has added a few more Silver Star recipients since Sergeant Zedwick. (OMD.)

3RD BATTALION CAVALRY DEPLOYS. An Eastern Oregon unit, the 3rd Battalion, 116th Cavalry, deployed to Kirkuk, Iraq, in December 2004 to assist in stability and support missions, working in close partnership with its Iraqi counterparts. Here, the battalion prepares to line haul from Forward Operating Base Beuhring to Forward Operating Base Warrior. (OMD.)

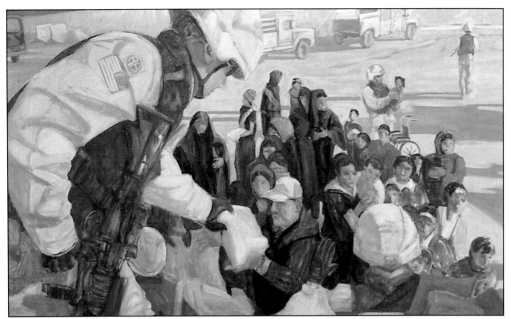

PROMOTING STABILITY. While serving in Iraq, soldiers of the 3rd Battalion, 116th Cavalry, helped secure the country's first free elections in over 50 years, helped train their counterparts in the new Iraqi Army, and participated in community events such as opening a medical and dental health clinic, reconstructing a local mosque, completing a new girls' secondary school, and handing out food and goods. (Carol S. Poppenga painting, OMD.)

HURRICANES KATRINA AND RITA. Oregon Guard members were among the first arriving in September 2005 to support hurricane recovery. Because of their unique role of being both federal and state, they could be mobilized to help with this natural disaster. The 41st Brigade mobilized within two days and sent over 2,300 troops to Louisiana and Texas to provide security, search and rescue, and set up communication links between agencies. (OMD.)

LARGEST DEPLOYMENT SINCE WORLD WAR II. The 41st Infantry Brigade deployed 950 soldiers to Afghanistan in June 2006 to serve as Taskforce Phoenix, training the Afghan army and police. The 41st soldiers lived and worked with their Afghan counterparts, bringing better understanding between the two worlds. Here, Maj. Robert Fraser helps to distribute supplies. (OMD.)

BRIG. GEN. DOUGLAS PRITT. Brigadier General Pritt (center rear) eats with his staff and Afghani partners. Brigadier General Pritt led deployment of the 41st Infantry Brigade to Afghanistan. Impressed with the professionalism of the National Guard force, he said Guard members bring something different when they deploy due to their maturity (most Guard members are older than their active-duty counterparts) and their civilian skills, which ultimately enhance the mission. (OMD.)

EVEN LARGER DEPLOYMENT. In 2009, the 41st Infantry Brigade again broke its own record for largest activation since World War II when over 3,000 soldiers deployed to Iraq. One of their main missions was to escort road convoys. The 41st provided convoy escort for over 6.5 million miles. These soldiers also participated in many friendship-building activities, including handing out shoes and books to Iraqi children. Here, the 41st runs during pre-deployment. (OMD.)

TASK FORCE STETSON. During the 2009 deployment, Task Force Stetson consisted of the 1st Battalion, 82nd Cavalry, and the 41st Special Troops Battalion. Their mission was headquartered at Camp Liberty, Iraq, where they did force-site security, consisting of manning the entry control points and towers and providing a quick reaction force, personal security, and convoy security. Here, cavalry battalion squad automatic weapon (SAW) gunner Spec. Isaac Bailey relays messages over the radio. (OMD.)

Task Force Columbia. This task force's mission was to oversee physical security of the entire complex surrounding Baghdad International Airport, which included over 65,000 soldiers. Lt. Col. Ken Nygren, the force protection and access control director, managed the process of moving equipment on and off base. He stated that "people want to move at a pace that is much faster than the pace allowed to maintain security." (OMD.)

Route Clearance. The 162nd Engineers also deployed to Afghanistan in 2009, providing route clearance to the troops there. The 162nd found and detonated over 200 improvised explosive devices (IEDs) during its time in Afghanistan. (OMD.)

TASK FORCE GRIDLEY. Oregon's 1249th Engineer Battalion deployed 75 soldiers to Afghanistan in December 2010 to participate in Task Force Gridley. Task Force Gridley's mission was to deliver supplies, manage civil military contracts, and perform construction and civil support missions such as delivering school supplies to Afghan children. (OMD.)

OREGON GOES HIGH TECH. The unmanned aerial reconnaissance (UAV) unit based in Pendleton, Oregon, deployed 18 pilots to Iraq in 2010. These UAV pilots used drone aircraft to provide real-time video feeds to commanders on the ground, solving an age-old problem with this high tech equipment. (OMD.)

41ST INFANTRY DIVISION ARMED FORCES RESERVE CENTER. Completed at Camp Withycombe and dedicated in September 2011, the 41st Infantry Division Armed Forces Reserve Center hosts nine Oregon National Guard and eight US Army Reserve units. Named to honor the 41st Infantry Division "Jungleers" in World War II, it is the largest facility built by the Oregon National Guard.

SENTRY EAGLE. In 2015, the 173rd Fighter Wing in Klamath Falls hosted the largest Air National Guard air-to-air combat competition, with 10 different states competing over two days. This open competition and display allowed the public to get a close-up view of Air National Guard pilots and their airplanes, such as the older F-86 Sabre and the current F-15 Eagle. (OMD.)

MAJ. GEN. RAYMOND "FRED" REES. Oregon's second longest-serving adjutant general, Rees's leadership spanned from the Cold War total mobilization concept to being an operational reserve for the Global War on Terrorism. Under his command, the Oregon National Guard led the way in multiple deployments from Desert Storm through service in Iraq and Afghanistan. Every Oregon National Guard unit successfully mobilized at least once during his command. (OMD.)

BIBLIOGRAPHY

Bruning, John R. *The Devil's Sandbox: With the 2nd Battalion, 162nd Infantry at War in Iraq*. St. Paul, MN: Zenith Press, 2006.

Carey, Charles H. *General History of Oregon*. Portland, OR: Binfords & Mort, 1971.

Cozzens, Peter, ed. *Eyewitnesses to the Indian Wars, 1865–1890. Volume 2, The Wars for the Pacific Northwest*. Mechanicsburg, PA: Stackpole Books, 2002.

Cross, Maj. Osborne. Report published in 1851 and republished as *March of the Regiment of Mounted Riflemen to Oregon in 1849*. Fairfield, WA: Ye Galleon Press, 1967.

Gantenbein, Brig. Gen. Calvin U., compiler. *The Official Records of the Oregon Volunteers in the Spanish War and Philippine Insurrection*. Salem, OR: State Printer, 1902.

Glisan, R. *Journal of Army Life*. San Francisco, CA: A.L. Bancroft & Co., 1874.

Hamel, Lt. Col. Alisha, SFC Kevin Hartman, Sgt. Cherie Cavallaro, T.Sgt. Jennifer Shirar, and S.Sgt. John Hughel. *Oregon Military Department: 150 Years Through Time*. Salem, OR. Oregon Military Department, 2009.

Hellis, T.Sgt. Lori, ed. *Guardians of the Pacific Northwest, Oregon Air National Guard: A Commemorative History, 1941–1991*. Dallas, TX: Taylor Publishing, 1990.

McCartney, William F. *The Jungleers: A History of the 41st Infantry Division*. Nashville, TN: The Battery Press, 1980.

Nelson, Herbert B. and Preston E. Onstad, eds. *A Webfoot Volunteer: The Diary of William M. Hilleary 1864–1866*. Corvallis, OR: Oregon State University Press, 1965.

Oregon National Guard. *Historical Annual National Guard of the State of Oregon 1939*. Baton Rouge, LA: Army & Navy Publishing, 1938.

The Third Oregon Infantry on the Mexican Border. Portland, OR: Oregon National Guard, 1916.

Victor, Frances Fuller. *The Early Indian Wars of Oregon: Compiled from the Oregon Archives and Other Original Sources, With Muster Rolls*. Salem, OR: State Printer, 1894.

Westerfield, Hargis. *41st Infantry Division: Fighting Jungleers II*. Paducah, KY: Turner Publishing Co., 1992.

Zucker, Jeff, Kay Hummel, and Bob Høgfoss. *Oregon Indians; Culture, History & Current Affairs*. Portland, OR: Western Imprints, Oregon Historical Society, 1983.

Discover Thousands of Local History Books Featuring Millions of Vintage Images

Arcadia Publishing, the leading local history publisher in the United States, is committed to making history accessible and meaningful through publishing books that celebrate and preserve the heritage of America's people and places.

Find more books like this at
www.arcadiapublishing.com

Search for your hometown history, your old stomping grounds, and even your favorite sports team.

Consistent with our mission to preserve history on a local level, this book was printed in South Carolina on American-made paper and manufactured entirely in the United States. Products carrying the accredited Forest Stewardship Council (FSC) label are printed on 100 percent FSC-certified paper.